Printmaking for Beginners

CPG	EBA	
9/5/01		
TOT	OSG	FRI

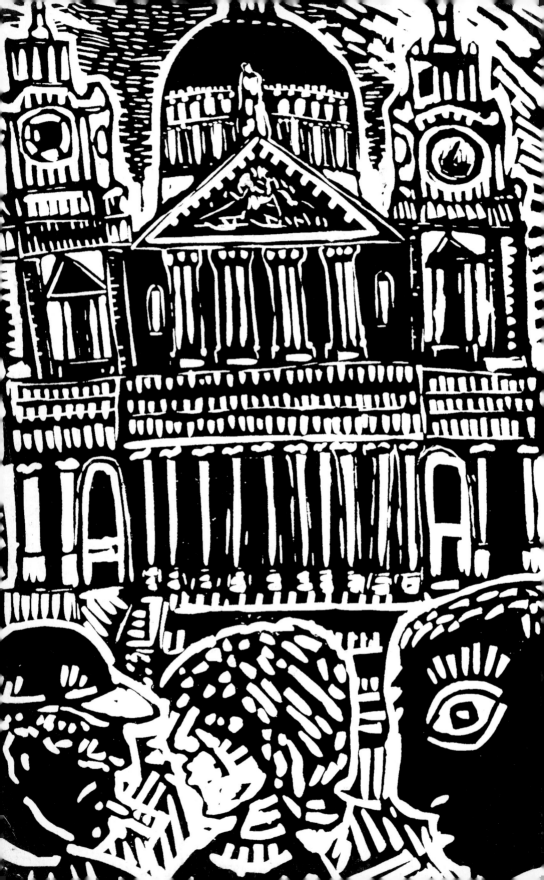

Printmaking for Beginners

JANE STOBART

A & C BLACK • LONDON

For Harry Eccleston

First published in Great Britain 2001
A & C Black (Publishers) Limited
35 Bedford Row, London WC1R 4JH

ISBN 0-7136-5037-0

A CIP catalogue record for this book is available from the British Library.

Jane Stobart has asserted her right under the Copyright, Design and Patents Act, 1988, to be identified as the author of this work.

Front cover illustration: *Mexican Market* by Laura Reiter (87cm x 57cm/34.5in. x 22.5in.)
Back cover illustration: *Old Bell* by Jane Stobart (36.5cm x 26.7cm/14.5in x 10.5in.)
Frontispiece: *St. Paul's* linocut by Stephen Mumberson (37cm x 51cm/14.5in. x 20in.)

Designed by Janet Jamieson
Cover design by Dorothy Moir

Printed in Malaysia by Times Offset (M) Sdn. Bhd.

Publishers note: Printmaking can sometimes involve the use of dangerous substances and sharp tools. Always follow the manufacturer's instructions and store chemicals and inks (clearly labelled) out of the reach of children. All information herein is believed to be accurate. However, neither the author nor the publisher can accept any legal liability for errors or omissions.

CONTENTS

ACKNOWLEDGEMENTS

Thank you to all of the artists who so generously shared with me their printmaking methods and for allowing their work to be reproduced in this book.

Thanks also to:

Toni Bailey
Joanne Bawden
Richard Bawden
Chloë Cheese
Bernard Cheese
Katie Clemson
John Fenton-Jones
The Folio Society
Rebecca Hossack
Simon Hughes-Stanton
Stanley Jones
Vijay Kumar
The staff at Intaglio Printmakers, London

The staff at T. N. Lawrence, London
Jacquie Newell
John Panas
Redfern Gallery
Sam Rothenstein
Judith Russell
Mustafa Sidki
Rosemary Simmons
Andrew Stasik
Margaret Steiner
Rebecca Toms
Maxine Trick
Angie and Brian West
Linda Wu

Chapter 1

INTRODUCTION

■ Printmaking has fascinated artists for centuries. Each method offers unique qualities and possibilities, quite unlike that of any drawn or painted mark. Never totally direct, this art form adds an element of surprise to the proceedings, akin to that of alchemy.

It is interesting to note, the next time that you are at an exhibition of original prints, that the huge variety of work before you is made up of just six basic methods: monotype, relief, intaglio, screenprinting, lithography and more recently, digital printmaking. Textbooks will give you an insight into methods but there is room for a great deal of experimentation once the basic principle of each discipline is understood.

The prints shown in this book are by beginners and accomplished artist-printmakers, using simple methods which you can try for yourself. Many of the the tools and materials are available from supermarkets and DIY stores, making it extremely easy for anyone to organise a basic printmaking set-up at home.

The definition of an original print
There has been much debate in recent years in an attempt to determine the watertight definition of an original print, as opposed to a reproduction (such as a poster). It would be convenient to imagine that, unlike a commercial printer, all artist-printmakers create the plate, block or screen by hand and then take all of the prints from it.

However, many artist-printmakers use photography or computer-generated imagery in their work and some employ professional editioners, taking it further into the apparent realms of commercial printing. The definition generally agreed is that however the artist-printmaker arrives at his or her final printed image, they have influenced and orchestrated the proceedings from the making of the matrix (block, plate, screen, etc.) through to the final print.

There are many scams on the market that the consumer needs be aware of. If buying a print termed 'original', one should be pretty safe in the knowledge that this has been at all times under the influence of the artist. If, however, the description is worded 'limited edition', but not 'original', then beware. Many limited-edition prints start life as watercolours or oil paintings and are merely reproduced by a commercial printer. The prints

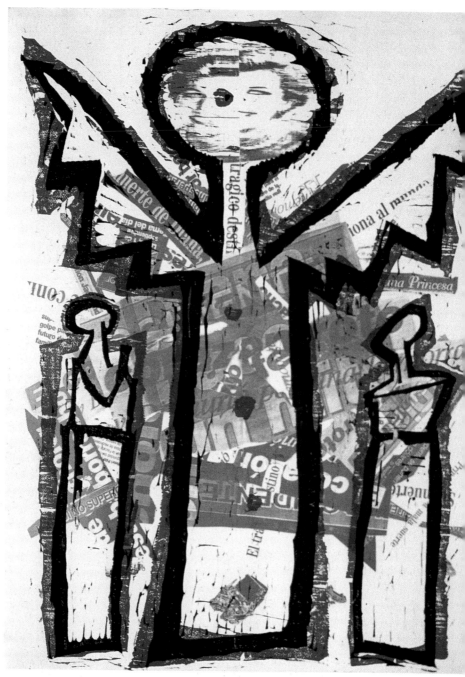

'Angel Diana' by Magnus Irvin, offset litho and woodcut, 76 cm x 51 cm (30 in. x 20 in.).
Magnus Irvin often challenges what we accept as printmaking, sometimes including paint and collage with printed images. His prints range greatly in scale and he also produces limited-edition artists' books.

are given an edition number and signed by the artist, making it look for all the world like an original print; but these reproductions have no actual value in terms of printmaking. The editions are often not very limited at all, sometimes numbering thousands, and, apart from being autographed by someone who is possibly quite famous, are worth little more than that of the autograph.

Trends towards safer printmaking

Several years ago COSHH (Control Of Substances Hazardous to Health) was introduced into British schools and colleges, forcing trends towards safer practices and working methods in printmaking, etc. (The United States of America and Australia have similar rules but by different names.) It is quite true to say that factories would not have got away with such casual treatment of hazardous materials, as most art schools did. Now,

'Before Dawn', unique print by Sandy Sykes, 56 cm x 81.2 cm (22 in. x 32 in.). This complex print involves hand-drawn etching on zinc, intaglio plates printed in relief (inked-up as for a lino block), in addition to stencils and woodcut. Some of the background colours are produced by chine collé (see Chapters Three and Four) and printed on hand-made *Khadi* paper which has a rough texture and quality. 'Before Dawn' is one of a series of 12 unique prints which Sandy Sykes worked on for two years.

however, safety laws have been tightened and all printmakers and print studios are aware of the potential dangers to their health and safety.

Very few art schools use oil-based screenprinting inks these days, due to the toxic nature of the solvents they require; most have adopted the use of acrylic or water-based systems. An increasing number of etchers are switching to ferric chloride, which is a safe and excellent substitute for acids, needing no system of fume extraction. White spirit as a solvent for inks, etc., has also been dropped in many printrooms and been replaced by cooking oil.

Of course, colleges have to take extra care in group situations, but working at home is different and simple precautions can be taken involving masks, goggles, rubber gloves and overalls, in addition to good ventilation. This book is not exclusively about non-toxic printmaking, as I believe that the printmaker should have a choice. I will draw attention, wherever possible, to safer alternatives.

Chapter 2

MONOTYPE

This method of printmaking is inexpensive, direct and exciting. Often favoured by painters, it allows total freedom of mark-making while offering all the qualities of a printmaking process. No press is necessary and with just a few tips you could be making excellent prints in next to no time. As the term suggests, monotype is a method of producing one unique print, which can be carried out in a single printing or in several printings on the same image. If you haven't got printing inks, oil paints can be used instead.

Outlined in this chapter are three methods of making monotypes, but this area of printmaking is open to much invention and there are many more possibilities.

Printing Inks for Monotypes

Oil, acrylic, rubber and water-based inks can all be used for making monotypes. These are available at specialist printmaking shops and will be of professional quality, but it is worth bearing in mind the characteristics of each ink type.

All of the good printmaking suppliers will send you their catalogue on request and the properties of the inks they sell are often described therein. The sales staff in most of these shops are extremely knowledgeable about the materials they sell and I have always found them to be a reliable source of practical advice.

'Under the Water at Night' by Caroline Wendling, 16 cm x 16 cm (6¼ in. x 6¼ in.).
This monotype has been made onto birch plywood sealed with shellac and printed on an Albion press; it involves three printings. A solid area of peachy-grey was printed first; next, the face and fish were painted onto the wood and printed on top; finally a roughly rolled transparent film of blue-green ink was printed over the other two.

Water-Based Inks

Some of the cheaper water-based inks on the market dry quite quickly, especially in warm weather, allowing less time for making the image. However, some are advertised as slow drying and it is worth checking these out. Others have a base of vegetable oil, but are still water washable.

Rubber-Based Inks

Prints made with rubber-based inks will take literally weeks or even months to dry fully on the paper, giving problems of storage and framing. Mixing in one or two drops of cobalt drier will speed up the drying time. These inks are not water-soluble and should be cleaned as for oil-based inks (see the end of this chapter).

'Yellow Tail' by Howard Jeffs, 76 cm x 56 cm (30 in. x 22 in.). Two-colour monotype made from a bevelled Perspex sheet using an etching press. A strong black, containing the drawn images, was printed over a solid burnt-orange printing to the very edge of damp Somerset paper.

Oil-Based Inks

These inks will form a skin on top while still in the tin; fold back the layer of skin and take fresh ink from underneath to avoid ruining your print. Although it appears expensive, buying ink in tubes will do away with wastage through skin and may therefore be cheaper in the long run.

Method One – Drawing into the Ink

This is one of the easiest ways of making a monotype. Make a few quick test prints, re-rolling the ink out after each trial print is taken. Making a print in this way will reverse your image.

1. Roll ink thinly onto a non-porous surface, such as a sheet of plastic or glass.

2. Check the ink layer for skin, removing with palette knife and then re-rolling.

3. Draw into the ink layer with anything that will make a mark – see p. 13.

Torn shapes of newsprint placed onto the ink prior to printing will mask areas out.

Ink applied with a palette knife. Both prints were made by the hand-burnishing method.

4. If clean edges are required, mask off the area to be printed with strips of newsprint or as shown on p.15.

5. Place printing paper over the ink image and rub firmly all over with the side of your fist.

6. Peel paper away. (See paragraph 'Getting a Good Print' on p. 14).

Sticks, palette knives, rag-covered fingers and a variety of household tools will all make interesting marks. A student of mine fashioned wooden tools specifically for making monotypes by this method. He whittled and sanded some sticks to create a crude set of implements to give a range of marks in the ink.

'Landscape '98' by Charles D. Rajkovic (Australia), 30.5 cm x 23 cm (12 in. x 9 in.).
Etching ink, thinned down slightly with medium copperplate oil, was rolled onto a steel plate. The image was created by 'working' the ink with stiff brushes dipped in turps. The print was made on an etching press, using dampened Fabriano paper.

Paper Suitable for Hand-Printing

Lightweight, smooth paper such as newsprint, cartridge or thin Japanese or Indian papers will print well with just the pressure of your fist. It is also worth experimenting with tissue, large manilla envelopes, photocopying or layout paper or anything else that you consider suitable. Unusual effects can be achieved by tightly screwing-up the paper, prior to printing, and then flattening it out again to create a 'cracked' texture. Heavier weight papers do not respond well to hand printing; see 'Printing with a Press', later in this chapter.

Getting a Good Print

When burnishing with the side of your fist, you can sometimes see the image coming through the back of the paper, giving a hint about the density of the print. Alternatively, you can check progress by peeling back the paper halfway to see the printed image. It can then be flopped back onto the ink and more fist pressure applied if necessary. Localised pressure from fingers or thumb nail will help to strengthen weak spots.

*'Pier Bell' by Jane Stobart
38 cm x 31 cm (15 in. x 12 in.).*
The image was painted onto clear, bevelled Perspex and printed on an etching press using dry Somerset paper.

Method Two – Painting with Printing Ink

This method of making monotypes will suit those with a painterly approach.

1. Using stiff brushes and/or palette knives, paint an image directly onto a non-porous surface using printing ink (mixing it well with a little medium copperplate or linseed oil beforehand will make it easier to work with). The image can be made in as many colours as you wish.

2. Place paper over the ink image and take a print with or without a press (if printing on a press, do not use glass).

If your inking slab is made from a transparent material such as plastic, Perspex or glass, you can place a drawn guide underneath.

This may also have the effect of increasing confidence and promoting freer and more gestural mark-making. If it is important for your image to print positively rather than in reverse, draw your guide heavily onto tracing paper and then turn the sheet over. Place this under your transparent base, backing it with white paper to ensure that you can see the guide clearly.

Method Three – Drawing onto the Back of the Paper
This method offers a unique, feathery quality of line.

1. Roll out a thin layer of ink onto your non-porous surface, checking for ink skin.

2. Lightly place thin, slightly textured paper such as a 70 gsm (grams per square metre) watercolour paper in a central position onto the ink.

3. Draw onto the back of the paper with a pencil, a stick, finger, comb, etc. The pressure of drawing will be enough to transfer the ink onto the paper.

4. Additional pressure made on the paper (accidentally or intentionally) will cause the ink to transfer. Selected areas can be firmly rubbed down with your finger or fist, which will result in a printed tone. Experiment with different pressures.

Should specific details be required, a guide can be drawn onto the back of the paper prior to making the print. If your print is too dark, reduce ink on the slab and make another. The print will be the reverse of the drawing.

Two-colour print made by monotype method three.

Certain two-or-more colour printings will necessitate exact positioning on to the ink, so that the various colours register together perfectly. This simple technique will ensure good registration.

MONOTYPE

Simple registration for colour printing

Registration is not always necessary for multicolour monotype print-ing, but if your image requires it, there is a simple way to ensure that your paper is placed in the same position on the ink each time. Trim your paper to the exact size of the inking slab. You can then register paper to slab edges, prior to each printing. With this method, a cartridge-paper mask (a window mount) can also be cut to the slab size (as shown previously) and be put in place before each printing.

Monoprint from wooden type
Several colours of printing ink were applied to wooden type using a number of small rollers, then printed with a roller through the back of Japanese paper to create a unique print.

Printing on a press

High-quality monotype prints can be made with an etching press, a converted mangle press or an Albion press (see Chapter Three, p. 42), if you are lucky enough to have access to one. The monotype image should be made onto a sheet of plastic, Perspex, a piece of sealed wood, a metal etching plate, but not glass. If using an etching press, all metal or plastic plate/block edges should be filed to a 45° angle; if this is not carried out, it may cut through the blankets on an etching press. Etching blankets can be substituted for two thick, army blankets. The pressure required on the press will be less than for printing intaglio, but enough to give the print an indented 'plate' mark, like that of an intaglio print.

Paper suitable for printing with a press

A press will enable you to use heavier weights of paper such as those suitable for watercolour or etching. These tend to be between 190 and 300 gsm and can be used damp or dry (heavily textured papers will probably print better when damp). Follow sections on 'paper preparation', 'printing' and 'flattening prints' in Chapter Four if you intend to use damp paper.

Cleaning-up

If you have used water-based inks, equipment can be washed under the tap (faucet) and dried thoroughly with cotton rags. You will use a lot of rags for cleaning up if you are going to carry out any sort of printmaking process on a regular basis, so it's a good idea to get friends and family to pass on to you all their old T-shirts and old sheets. Cotton and cotton jersey make the best, most absorbent rags.

Ink solvents

Oil-based or rubber-based inks can be cleaned using white spirit or turpentine and rags; make sure you have adequate ventilation. White spirit can cause headaches and allergic reactions on sensitive skin; rubber gloves can be worn when cleaning up. Turpentine substitute is apparently less likely to cause headaches. Pure turpentine is sweeter-smelling and even less offensive, although more expensive. I have recently spotted something called citrus turpentine in one shop, which claims to eradicate headaches altogether.

Alternatively, the cheapest vegetable oil can be used to remove ink, which is a method adopted now in many colleges. Oil will eventually remove all traces of ink but it takes a little longer. Finish off with a liberal spraying of a water and washing-up liquid solution, which will cut through any film of oil remaining. Dry equipment thoroughly after spraying.

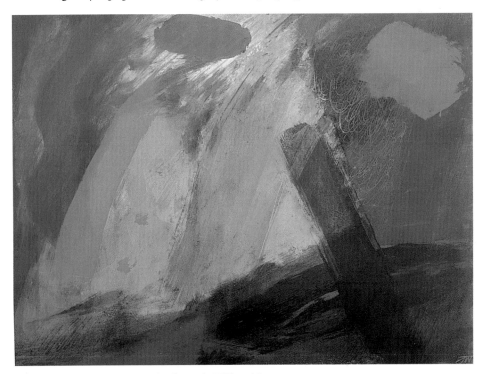

'Voyage', monotype screenprint by Judy Willoughby,
43 cm x 56 cm (17 in. x 21 in.).
This monotype was made using the screenprinting process. Water-based screen-printing inks were painted directly onto the mesh and the image transferred onto the paper by dragging transparent ink across the entire screen with a squeegee (see Chapter Six for printing details). Only one print can be produced, but several printings can be made onto the same image, as in this example.

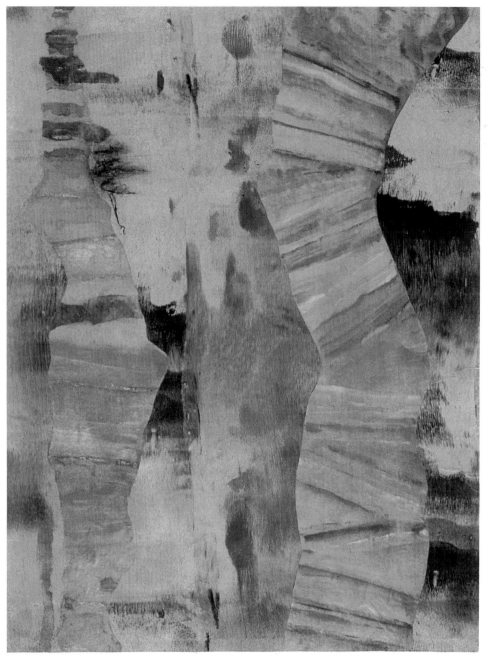

'L'Afrique Inconnue', monotype collage by Diane Miller (USA),
66 cm x 50.8 cm (26 in. x 20 in.), (collection of Michal and Gadi Benyaacov).
A monotype (mostly black) was printed onto orange paper with gold threads;
collaged over this are pieces of a second monotype which had been printed
onto the same type of paper.

Chapter 3

RELIEF PRINTING

■ This is the oldest form of printmaking and accessible to everyone, even those without a press. In relief printmaking, the uppermost surface of the material is inked-up, and printed from, as with a rubber stamp. The cut marks below the surface do not receive any ink and therefore will not print.

Although lino (linoleum) and wood are the first materials that spring to mind, they are far from being the only surfaces that you can cut into and print from. Cardboard, hardboard, multidensity fibreboard (MDF), cork, plastic, vinyl, potato and all sorts of found objects, both natural and manufactured, can be used to make relief prints.

Considering an image

With the exception of wood engraving, relief printmaking is not the most refined method of making a printed image. One should perhaps think in terms of bold shape and strong mark-making, rather than very precise detail. You may well prefer to cut spontaneously and intuitively into your lino, wood, etc., but some printmakers like to have a degree of control over the planning and composition of the image before cutting.

Rubber stamp made up from a frog lino print and a wooden-type print, both reduced on a photocopier and pasted-up together. The stamp was produced commercially and quite inexpensively, directly from the artwork.

Tracing down the image

Once you are happy with the drawn plan, turn the tracing paper over before transferring it onto the block, as printing will reverse your image. Carbon paper or 'carbon-less' transfer paper are both excellent for transferring the tracing onto the block using a ballpoint pen to draw through the paper. Re-drawing the image onto the block with a permanent marker will fix the cutting guide throughout proofing, cleaning and re-cutting.

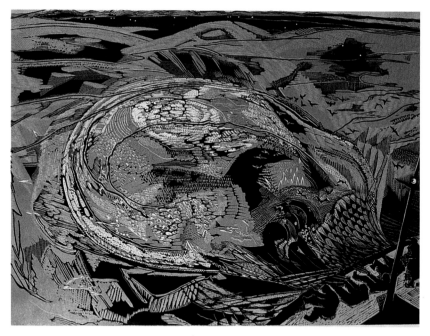

'Ring Net Fishers', linocut by Gertrude Hermes RA, 56 cm x 76 cm (22 in. x 30 in.). The linocuts of the late Gertrude Hermes RA were mostly made in three printings (three colours). Her dynamic cutting created a huge vocabulary of 'textures' and relief printmakers could learn a great deal from studying her prints (linocuts and wood engravings).

Cutting tools

'Artists' quality' or 'student quality' mushroom-handled woodcutting tools are wonderful for use on any relief material, but they are expensive. If you can afford them, you may find as few as two are perfectly adequate. Ask to try out a range of tools in any good printmaking supplier to discover which ones you prefer.

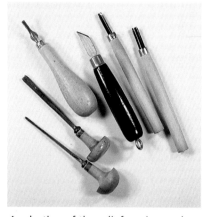

A selection of the relief cutting tools on the market.

There are some excellent and much cheaper alternatives on the market from Vietnam, which come in sets of six 'V' and 'U' tools in a plastic wallet. The steel cutting part is sunk into a straight wooden shaft which can be made more comfortable in the hand by wrapping several feet of masking tape around the handle. Most easily acquired are the detachable nib and handle cutters that can be obtained in most art and

stationery shops. These are fine for cutting warm lino, but are too flimsy for making woodcuts.

Japanese woodcut artists, and some Western relief printmakers, favour a knife over any type of gouge. There are two types, English or Japanese, both consisting of a sturdy blade fixed into a wooden handle. The wood or lino is cut away by making two incisions angled towards each other to remove a sliver of material.

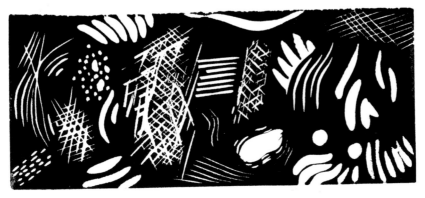

Experimental cutting block showing cutting techniques with a range of tools.

*'Sir Kay smote him so hard that the stroke clove his helm and head to the earth',
linocut by Edward Bawden RA, from Thomas Malory, 'The Chronicles of King
Arthur', 1982, 20 cm x 26.7 cm (8 in. x 10.5 in.) © The Folio Society Ltd, London.*
The late Edward Bawden has been a major influence on relief printmaking in the
United Kingdom, with his unmistakable, direct approach to cutting lino using only
a knife.

Sharpening the tools

Your tools should be extremely sharp when purchased, but cutting will blunt them eventually. Some printmaking suppliers will carry out a sharpening service at a cost, or you could consider doing it yourself. Work U-tools from side to side on an oil-covered arkansas stone, at the same angle as the bevel. V-tools should be rubbed up and down on the stone at the same angle as the bevel. A small 'slip' stone can then be run around the inside of each cutting edge to remove the burr. Sharpen knives using a circular motion on the stone.

Linocuts

Linoleum (lino) is easy to cut if the weather is warm (it can be warmed up in winter against a radiator) and if your tools are sharp. This material does not have a grain so there is no resistance in any direction. Beyond a certain level of fine cutting lino will crumble, so it is best to keep your cutting strong and bold. Cut to about half the lino thickness, but not as far as the hessian backing.

'Canetti's Crowds', woodcut/linocut by Ann Westley, 74 cm x 53.5 cm (29 in. x 21 in.).
The top section of this print is a four-colour linocut and the lower section, a two-colour woodcut made from pine.

Buying lino

Lino can be bought in small pieces from some art shops. It is hard to come by as a flooring medium these days, but if you can track down a supplier, it is cheaper to buy off the roll. 'Battleship' lino, as it is known, (or 'cork' lino), comes in two thicknesses. It is worthwhile contacting any of the flooring suppliers in your area and seeing if they will order you some. See list of suppliers, p. 109.

Relief-printing vinyl

As an alternative to lino, a Japanese vinyl block can be obtained from certain printmaking suppliers, which is double-sided and has an excellent cutting surface.

Etching lino

Lino can be etched quite effectively with various caustic materials such as oven-cleaning spray, paint stripper or by making your own caustic soda solution from crystals. I found caustic soda to be the most effective by far. When handling any sort of caustic substance, work in a well-ventilated room or outside on a calm day in a shaded position. Wear a sturdy pair of rubber gloves when making or using the etching

'Strata', (detail), vinyl print by Julie Carr, 55.9 cm x 80 cm (22 in. x 31½ in.). An old piece of flooring vinyl was used to make this unique print, cut into separate strata with a sturdy pair of scissors. Printing ink was applied to each shape by roughly rolling with ink, in addition to applying it with the fingers. The pieces of vinyl were reassembled and printed using a baren.

solution and keep a bowl of clean water handy in case of splashes on skin or eyes. Plastic goggles and a mask should be worn when mixing or spraying the 'etch', as well as an apron or overall.

Lino etched with caustic soda which has been brushed and sponged on, and left in a warm place for three to four hours. Stopping-out varnish (see Chapter Four) and melted candle wax will both resist caustic soda, preventing it from 'etching'.

'Townscape', etched lino by Frixos Papantoniou, 20 cm x 70 cm (8 in. x 27½ in.). Rough, knotty wood was placed onto a piece of lino that had been liberally coated with caustic soda. The wood was heavily weighted down and left overnight, causing the grain to etch itself into the impressionable surface of the lino.

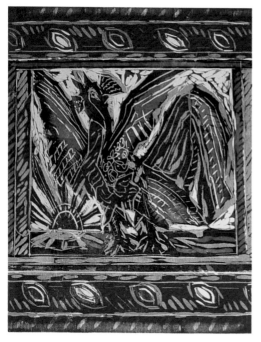

'Sunburst', woodcut by Michael Rothenstein RA, 74 cm x 57 cm (29 in. x 22½ in.). The late Michael Rothenstein made wonderfully energetic woodcuts, which were often jigsawed into separate pieces and inked-up independently, as in this example. This print was made from plywood, using traditional woodcutting gouges and knives in addition to an electrical disc sander, the effects of which can be seen in the top and bottom red/orange borders.

The caustic solutions will be affected by the climate, etching faster in warmer weather.

Caustic soda

You can buy caustic soda crystals from hardware stores. Always add crystals to water and never the other way around.

1. Place a quarter-pint (0.28*l*)of cold water in a glass jar and add a spoonful of the dry crystals; stir with a stick until dissolved. Repeat until the solution is saturated (no more crystals will dissolve).

2. The etching solution will become hot during mixing and should be allowed to cool before use. Add a little methylated spirits (meths) when cool to make more fluid.

3. De-grease the lino by wiping with meths and a clean rag or rub well all over with washing-up liquid and water (then dry thoroughly).

4. Resists can be made with candle wax (dry or melted) or stopping-out varnish

(see Chapter Four), before applying the caustic soda; these areas will remain un-etched.

5. Paint the solution thickly onto the lino with a nylon brush or apply with a stick or sponge. Mixing the caustic solution with prepared wallpaper paste will make it much easier to control on the lino surface. Begin with fifty-fifty proportions and leave overnight to etch.

6. Scrub the block with a stiff brush under running water when the test time is reached and leave to dry thoroughly between newspapers, weighting down with a heavy board to flatten.

Woodcuts

Woodcuts are made from the side grain of wood known as the 'plank'. Wood has a directional grain and there is not the same freedom of cutting as with lino. However, this resistance can result in more dynamic cuts, as you have to make a determined effort to make your image! When printed there should be evidence of the wood grain running through the uncut areas; the quality of printed wood is extremely beautiful, even without any cutting on the surface. Seal the woodcut by painting thinly with shellac (or button polish or knotting varnish); this will prevent the printing ink from being absorbed into the wood when inking-up.

Many printmakers working in this medium favour the fruit woods such as lime and cherry (a favourite of Japanese woodcutters), but all sorts of woods are worth trying. The grain can be made more pronounced by wetting the wood and then scrubbing vigorously with a wire brush to reduce the softer parts.

The coarse wood of packing cases will give the most pronounced printed grain, making an exciting and contrasting background to a finer woodcut or linocut, printed on top. Birch plywood is tightly grained and cuts beautifully, but with all plywoods, guard against cutting down to the

'Golden City', woodcut by Sasa Marinkov, 22 cm x 65.5 cm (8½ in x 25¾ in.). Cut from birch plywood, this print has been 'locally' inked by rolling up with a range of different colours.

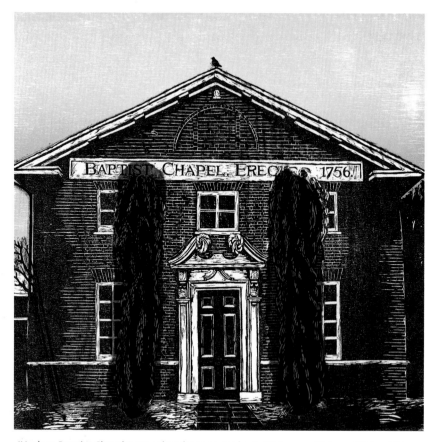

'Harlow Baptist Church', woodcut by Jane Stobart, 53.3 cm x 48.2 cm (19 in. x 21 in.). Rough pine plywood was used for the sky and birch plywood for the church in this woodcut. The green of the trees was made by 'chine collé' (see p. 66), where torn pieces of thin Indian paper were placed onto the inked church block, having been dabbed with the glue in stick form (this is more or less p/h neutral) on the side that meets the printing paper.

layer of glue beneath the topmost veneer, as this will blunt your tools. Mistakes in your woodcut can be rectified by applying wood filler – fill, sand down and re-cut. The wood grain in filled areas will be lost, however.

Wood engraving

Wood engravings are made on the tight cross grain of timber such as box, pear, lemon and hornbeam woods, the most highly regarded and expensive being box wood. A type of engraving plastic can also be used and is favoured by some relief engravers; this is a totally different process from intaglio metal engraving.

Wood-engraving blocks need to be professionally planed and prepared and are purchased from specialist printmaking suppliers. After engraving, the blocks can be resurfaced and used again.

Above: 'Patterned Tongue Sole',
wood engraving by Mandy Bonnell,
6 cm x 14 cm (2¼ in. x 5½ in.).
This little print is one of a series of
wood engravings of Kenyan coral fish;
it is taken from an exquisite, limited-
edition, hand-printed book, produced
by the artist.

Left: 'Lords', colour relief engraving
by Edwina Ellis, 16.4 cm x 10 cm (6½ in.
x 4 in.). From the London Transport
poster by Edwina Ellis, © London
Transport.
Edwina Ellis cuts up to three separate
blocks for each of her colour relief
engravings. 'Lords' is cut on a polymer
resin material called 'Delrin' (by
DuPont), which she favours over tradi-
tional box wood. The blue block was
cut first, and then prints from it were
offset onto two more blocks, to act as
cutting guides. The additional printings
were red and yellow.

Wood-engraving tools

Wood-engraving tools are totally different from the gouges used for lino
and woodcutting; they are basically sharp steel rods, set in mushroom-
shaped handles, which channel out slivers of wood from the tight surface.

1. square scorper a square ended tool for clearing out areas or making broad lines.

2. tint tool gives an even width of engraved line – used for hatching and shading.

3. round scorper for making broad lines/ stipple dots/ clearing out areas.

4. graver for fine or broader lines, depending on depth of cutting.

5. chisel tool for clearing out large areas smoothly.

6. spitsticker for curved lines; rotate the block as the tool travels through the wood.

7. multiple tint tool has a number of points at the end for cutting parallel lines/cross-hatching.

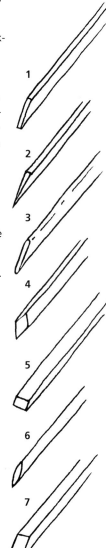

Test print from lemon wood showing engraving techniques using a range of tools and printed by burnishing with a metal spoon.

Darkening the block

When woodcutting and wood engraving, paint the block with black Indian ink prior to cutting. A pencil tracing or drawing will show up clearly on the black surface as a cutting guide (remember to reverse your tracing first). Each cut mark will expose the colour of the wood beneath, making it easy to see your evolving image.

Cutting the block

Traditionally, this method of printmaking is for producing small, controlled images with fine cuts which are usually printed in black. The engraving tool should be held almost parallel with the surface of the wood, whilst the other hand holds the block. It is usual to sit the engraving block on a circular cushion of leather filled with sand, so that the block can be turned for a curved cut, rather than the tool. You could improvise with a home-made sandbag. For printing wood engravings, see p. 40.

'Sherbet, Istanbul', cardboard cut by Sheila Robinson, 69 cm x 33 cm (27 in. x 13 in.).
Colour print made from sturdy cardboard by cutting the whole image out and discarding the background. The three main sections were cut apart, and details were scored into, or torn away, to create lower levels. Some areas were inked by dabbing on colours with the finger. Finally, the three pieces were reassembled like a jigsaw puzzle, and printed together, using an Albion press.

'Fragile Institutions', wood engraving collage by Anne Desmet, 20.5 cm x 13 cm (8 in. x 5 in.).
After printing many copies of two engravings, selected details from the prints were cut up, reassembled into towers and collaged onto two gessoed, painted panels. Other collage elements include parts of a 1,000-lire banknote.

'Harlow', cardboard cut by Jade Dellar, 52.4 cm x 38 cm (20½ in. x 15 in.).
Student print made entirely from mounting card. The background buildings were scored and stripped to create two levels and printed first, with the shape of the sculpture missing. Rodin's 'Eve' is a reduction cardcut, printed into the vacant gap. See p. 32 for reduction method.

Cardboard prints

Cardboard is easy to cut and strip away, giving a soft printed texture. With treatment it will withstand inking, printing and even cleaning. See prints on pages 29, 30 and 31.

Other materials to try

Relief prints can be made from virtually any surface that you can cut into. See prints on pages 30, 31 and 32.

Left: Untitled cardboard relief print by Alison Newson, 28.1 cm x 6.4 cm (11 in. x 2½ in.). Three levels have been created in this print by building up from the original card surface, in addition to stripping down a level. Raised surfaces can be made from sellotape, masking or insulating tape, gummed paper, fine-textured fabrics or PVA glue. Lower levels are achieved by cutting or tearing the topmost surface away. White lines can be created by drawing hard into the card with a ballpoint pen. Seal prior to printing.

'Big Head I', mixed-media image by Linda Wu, 213.4 cm x 137.2 cm (7 ft x 4 ft 6 in.). The head section of this mixed-media image is a giant hardboard cut, printed by hand-burnishing method. Other parts of the image were carried out in watercolour and collage.

'Frieze', by Sue Ashton, 30.5 cm x 40.9 cm (12 in. x 16 in.).
Student print made by the reduction method from one piece of foam board,
coated with shellac after each cutting and printed on an Albion press. The prints
were made onto a variety of surfaces including textured watercolour paper, as
shown here.

Carrying out a colour print

Reduction block method

Although it is usual to print the lightest colour first and then print
progressively darker, in a number of reduction lino prints by Picasso, a
solid black was printed first. Next, he cut a linear image and printed it in
white onto the black. The lino was further reduced and three small areas
of bright colour were printed onto the white. The results were stunning
and acted as a reminder that there are no hard and fast rules in these
matters. See reduction method in illustrations on p. 33.

Multi-block method

If you are not a confident colourist, you may wish to cut separate blocks
for each colour to be printed. This will enable you to proof them all up
together in different colours and strengths of colour, before deciding upon
the most successful combination. This method is suitable for making
multicolour prints from any of the materials mentioned.

1. Cut the last block to be printed **first**. This is usually the darkest printing
 and the most detailed of the blocks – think of it as the key block.

'Checking the Inscription', reduction linocut by Jane Stobart,
15 cm x 10 cm (6 in. x 4 in.).
Ingenious and cheap way of making colour prints from just one piece of
lino/wood/etc., which involves cutting and printing the block in stages.
(i) Any 'white' areas are cut out first and the block printed in the lightest colour
(murky brown). Make quite a few of these prints, as once you re-cut the block
(for the second printing), you can never reprint the first. (ii) Cut the block again
for the second colour (blue-grey) and print on top of the first (see 'Registration').
(iii) Finally, re-cut for the third and last time and print on top of the other two
(this will be the darkest colour).

RELIEF PRINTING

2. Make a good, strong print of this in black and then offset the print (not the block) onto the other blocks to be cut. These should be slightly larger than the print.

3. Allow to dry completely, then trim down the additional blocks to the exact size of the image printed on them. When oil-based inks are dry they become permanent.

4. Cut the new blocks for each additional colour required, using the offset image as a guide. Remember that areas common to two or more colours will overprint to create other (bonus) colours; e.g., a transparent blue printed over an area of yellow will make green.

'Autumn Exbury', linocut by Katie Clemson (Australia),
26 cm x 26 cm (10¼ in. x 10¼ in.).
Reduction linocut – six printings.

Printing inks

Inks used for relief printmaking can be waer-based, oil, rubber or acrylic-based. See p. 12 for a description of ink properties.

Making ink transparent

A colourless, transparent ink can be added to oil-based, water-based or rubber-based inks to reduce the strength of the colour, making black into grey and red into pink. This colourless ink is called 'reducing medium' (or 'reducer', 'tinteen', etc.) and I always keep a large tin in my own workshop, or in any printmaking class over which I preside. It turns opaque ink into a thin film of transparent colour, making it excellent for overprints. It also improves the viscosity (consistency) of ink, even black. I have found, over the years, that I use far more reducing medium than actual inks.

Stripping the ink

No matter how many colours are printed onto Japanese paper, they will be absorbed and dry to a matt finish, making it the most prized of relief printing papers. On cartridge paper, inks will dry to a shiny finish which can be minimised somewhat by 'stripping' the ink immediately after printing. This is done by simply placing a clean piece of newsprint paper over the entire printed area and rubbing it firmly with the side of the fist. Stripping the ink results in a thinner film of printed colour. If a heavier weight of paper is preferred, Somerset, Arches 88 and Zerkall 7625 are quite absorbent and print well.

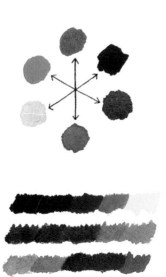

Which colours to buy

A little knowledge of colour theory will save you a great deal of money on ink. The most subtle of colours and all of the neutrals can be made from the three primary colours. See the colour ink chart.

The three primary colours of ink – red, yellow, blue – will make the three secondary colours – orange, green, violet. Mixing together the opposites on the colour wheel – yellow/violet; blue/orange; red/green – will make colours less bright and more subtle, eventually neutralising them completely.

Inking-up

It is important, when embarking on relief printmaking for the first time, to be experimental at the printing stage; keep a variety of papers to hand. When inking-up, you will learn to read the surface of the inked block. In short, what you see is what will print; if the inked surface looks stripy and uneven, so will the resulting print.

Some images will benefit from just one flat, beautifully printed colour and this is an excellent way to start learning about printing. You will soon find out the right amount of ink to make an even and true print. Too little

'Stingray' linocut by Allan Palm Island (Australia), 460 x 420mm/18⅛ in. x 16½ in. Five colour reduction lino print (from a single block) printed on 300gsm Magnani, Pescia 2010 paper. Allan's work represents the traditional foods and ceremonies of the Manbarra people, the indigenous title holders of Palm Island, situated off the coast of Queensland.

ink and the resulting print will be ghostly and dry-looking, whilst too much will look textured on the lino block and ink will spill over into your cut marks when printed, losing finer cuts altogether. The perfectly inked lino block will be a smooth and shiny surface.

If you are irritated by the inking-up of the texture left by the cutting tool in the non-printing parts, you can cut out these areas of the lino altogether using a craft knife. Alternatively, the offending texture can be wiped of ink with a rag-covered finger.

Rollers

The perfect roller will be wider than your relief block and as big in diameter as you can get. These can be very expensive and there is much choice with regard to the roller material. In the printmaking catalogues you will see rollers made of gelatin, treothene, polyurethene compositions, etc. These tend to be soft and beautiful to use, but their life is not long, and I have replaced all of my 'dead' ones with high-quality rubber which should last a very long time. Rubber can be bought in hard or soft surfaces. The newest roller material on the market is called durathene which is a smooth, soft material, and manufacturers claim that it will not revert to liquid in time.

Monoprinting on your lino block

To get a unique print, you could try some of the monotype inking techniques on the surface of your block. Also, try inking with a few small rollers, one for each colour, which will blend as they overlap. This is known as localised inking.

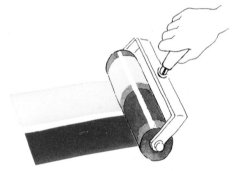

Colour blends can be achieved by making two stripes of different inks onto the inking slab. Work the roller onto these again and again until the two bands of ink have transferred evenly onto it. Gradually work the roller from side to side (keeping it parallel with the ink stripes) until the two colours begin to blend in the centre.

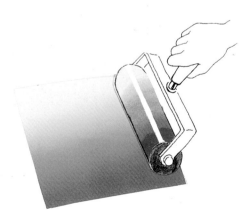

Paper

There are some extremely exciting papers in the art shops these days, many from India and Thailand. A good paper supplier will have a seductive stock of brightly coloured and heavily textured papers with such pulp additives as tea, flower petals, straw, algae, hair, etc.

Hand-made papers

If considering hand-made paper, look for a smooth surface. Some of the brightly coloured Indian papers are wonderful, but the strong colour will obviously influence your printed colour and could dominate certain images. The Japanese papers that I favour for printing without a press are *Tonosawa* – a relatively inexpensive and small sheet-size Japanese hand-made paper. This is excellent for printing by burnishing. Some of the Japanese machine-made papers are also very good for hand printing and are cheaper than hand-made papers.

Other papers

For printing without a press, make a wide-ranging collection of light-weight papers such as brown wrapping paper, tracing paper, grease-proof, newspaper text pages, as well as cooking foil, wallpaper, graph paper, 'layout' or photocopier paper, newsprint and tissue.

If you have access to a press then you can use a heavier weight of paper for printing. Some of the textured papers will give interesting effects but may have to be dampened first.

Decorative papers from India, Japan and Thailand.

Dampening paper

This can be carried out using a house-plant spray, holding up the paper in the garden, or laying it down on newsprint and spraying evenly all over each side. Place paper between blotters and sandwich between polythene (sheets of acetate or portfolio sleeves), to prevent drying out. Weigh down with a piece of wood or a drawing board to squeeze the excess moisture from the paper and keep it flat. Leave paper for an hour or longer; it should be completely damp but with no surface water visible on either side by the time you print.

Printing

Proofs

It is advisable to take 'proofs' (prints en route, also known as 'states') regularly, to see how your work progresses.

Printing without a press

You can print all sorts of relief blocks successfully without the use of a press, but as mentioned earlier, your choice of paper is important. Slightly more ink may be needed for printing by hand and the addition of reducer-base will improve viscosity and make the ink less stiff. See 'Inking up' p. 36.

Lay thin, smooth paper over the inked block – this should be larger than the block. Using a clean roller or a large spoon, work firmly over the back of the paper. A spoon is an excellent printing device, as it allows you to get your thumb inside the bowl and bring a good deal of pressure to bear. Work in small circular movements, burnishing the paper onto the ink. If using a roller to print with, roll in different directions. You may see your image emerging through the reverse side of the paper, but if not, peel the print halfway back to check on quality and flop back onto the ink if more burnishing is required. On large blocks place a weight or two onto the paper margin to keep from moving.

The Japanese baren

The traditional Japanese method of taking a print is with a device called a 'baren' and it is favoured by some Western relief printmakers. A baren is made from a bamboo husk covered by a bamboo leaf and can be obtained from most printmaking suppliers. The leaf is twisted around the back of the husk to form a handle; slip your hand inside this loop and press down to burnish the back of the paper onto the inked block. When the bamboo leaf wears out, replacements can be bought. There is also a PVC disc baren on the market.

Proofing relief engravings

Ink should be rolled on thinly to avoid the fine cuts filling with ink.
Excellent prints can be taken without an Albion press or by burnishing
the back of the paper with a metal spoon, a box-wood burnisher or a
smooth stone. Paper should be thin and smooth – layout paper is ideal.

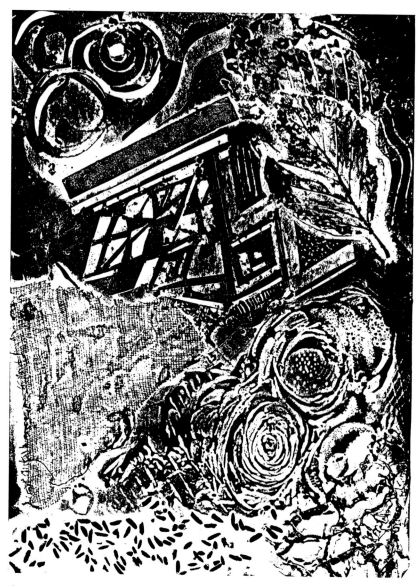

Constructed relief block by Jacquie Newell, 19.5 cm x 14 cm (7.6 in. x 5.5 in.).
All the elements in this print were stuck onto a firm base and then thoroughly
sealed with shellac-based varnish. The inked block was printed by burnishing with a
metal spoon.

Edwina Ellis suggests taking proofs on tracing paper or draughting film, and when dry, the ink image can be scratched away, to plan your next cutting strategy.

Printing with a press

An Albion or Columbian press is what most relief printmakers dream about owning one day. These cast-iron, Victorian presses are beautiful to look at and often very decorative. When set up properly, they should print all relief work with ease and efficiency. Designed for proofing letterpress type, they can still be obtained, but are expensive, due to their antique status and relative rarity. Artists' and printmakers' magazines sometimes advertise presses for sale, so if you are thinking of buying one, keep your eye on the small ads.

The letterpress proofing press is another useful press for printmakers; it was used by printers in the days when most commercial printing was carried out with metal type. It consists of a long narrow bed (usually 33 cm/13 in. wide), onto which inked type (or a relief block) is placed with paper on top. An attached roller is pulled across the paper to make the print. Other presses based on the Albion design, as well as book-binders' platen presses, mangles, mechanical platen presses and hydraulic presses, can occasionally be bought secondhand.

Balsa is the easiest of woods to make an impression upon. Here, a piece has been cut with a craft knife, incised with a sharp metal point and cut with gouges, then printed on an Albion press.

Getting the pressure right

The right pressure required to take a 'true' print, using an Albion or Columbian press, can be gauged by using your un-inked block. Place it on the press bed, pull down the tympan (stretched frame which keeps paper in place) and roll under the 'platen' (the rectangle that bears down on the block). Ideally, when pulling the press handle to print, you should feel a resistance; the handle should be pulled across completely and then be guided back into the original position. Some packing will definitely be

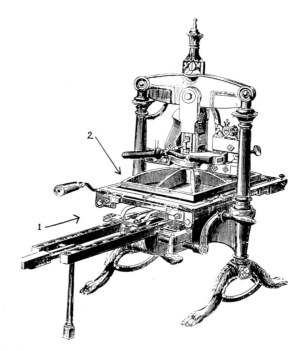

Victorian Albion press.

1. Inked relief block and paper are placed onto the press bed and wound under the 'platen'.
2. Platen is brought down onto block, making a print by pulling the pressure handle towards printer standing on furthest side.

required to adjust the pressure, and much time and effort can be saved by collecting a range of bed-sized pieces of wood, card and hardboard, as well as newspaper and blotting paper for the final adjustment. If printing from card or lino, place hard packing (wood is ideal) underneath the block to get close to the height required. You can print with the paper on top of the block, or the other way round with these presses, but always have some soft packing (newspaper or equivalent) next to the paper.

Letterpress roller presses will need a similar process to get the pressure right for the thickness of the printing block. With these proofing presses, lino can warp if your printing paper is not uppermost (with lino underneath) when printing.

Modern presses

Many contemporary presses are designed for more than one printmaking process. There are etching presses on the market now that can be quickly converted for relief printing, in addition to lithographic printing. Always research thoroughly if considering buying a press – talk to printmakers, tutors and technicians in colleges, to find out what more experienced printmakers prefer.

'Ice Crystal', (detail) blind embossed linocut by Mustafa Sidki,
12.6 cm x 11.5 cm (5 in. x 4.5 in.).
'Blind embossed' is the term for 'printing' with no ink, and heavy pressure, so
that the relief shape alone is pressed into the paper. Dry blotting paper has
been used to make this impression.

Registration

When making colour prints, you will need to position each separate
printing into a specific position onto the paper, to register the colours
together. There are several registration methods you can adopt, but by far
the simplest and most basic is the following:

Single sheet registration

1. Firstly, trim a sheet of cartridge paper to the size of your
 printing papers.

2. Place this base sheet onto the press bed (or a table if not using a press).

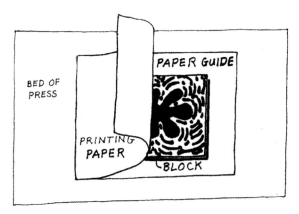

Relief
registration
method.

3. Position your dry block in the centre of the base sheet and draw closely around it using a sharp pencil or fine pen. Remove block and ink-up.

4. Each time you take a print, place the inked block accurately into the drawn box.

5. Place the printing paper exactly in line with one corner and one corresponding side of the base sheet and allow it to settle onto the inked block.

6. Print by press, roller, baren or spoon.

7. Repeat this method to print second colour onto first, and so on.

Cleaning up

See section on solvents at the end of Chapter Two for cleaning equipment and surfaces. Remember also to clean your printing block, as reprinting later could be affected by an old, dry layer of ink.

It is worth noting that white spirit will eventually harden rubber rollers with wooden cores. However, cooking oil appears to be absorbed into the rubber veneer after a while, causing it to expand, eventually it becomes separate from, and bigger than, the wooden core. Old oil can build up around the sides of rollers if not cleaned off really thoroughly, which restricts the freedom of roller action.

For more information about aspects of relief printmaking, please see *Relief Printmaking* by Ann Westley, in this series of handbooks.

Chapter 4

INTAGLIO
PRINTING

Intaglio printmaking is the direct opposite of the relief process; ink is transferred onto the paper from the lower levels of the plate. Etching, aquatint, engraving, mezzotint and drypoint are all intaglio processes. Most printmakers start to learn about intaglio by making dry points, etchings and aquatints, and these will be explained fully in this chapter. For other intaglio methods, I refer you to *Intaglio Printmaking* by Ken Duffy in this A&C Black series.

It is vital to have access to an etching press or converted mangle press to carry out any sort of intaglio print. The amount of pressure needed to force the paper down into the depths of a plate are immense and cannot be substituted effectively by any other means.

Drypoint

What is a drypoint?

Drypoint is the simplest intaglio process involving no grounds or mordants. An image is made by scratching onto a metal plate, a plastic sheet or specially coated card, with a sharp point. The scratched lines, being lower than the original surface, can receive ink and print.

A drypoint line has a richness unlike that of any other intaglio line quality and it does not take long before you can easily identify a drypoint print. The reason for this is that unlike engraving or etching, no metal is actually removed (apart from a little dust); instead, the metal is displaced into a 'burr'. The burr is metal thrown up to the sides of the scratched line, rather like the curl of a wave. The printing ink is held under the burr, as well as in the scratched line, giving a beautiful, velvety quality to the printed line. Once the burr is worn away, the strength and characteristic of the line is diminished and weak. A drypoint plate should be treated with the utmost care once produced, as any pressure will shorten the life of the burr.

Checking on progress

The action of printing will steadily cause the burr to wear down, so proofing (prints taken to check on progress) should be avoided until the plate is completed. A mixture of printing ink and vaseline can be rubbed

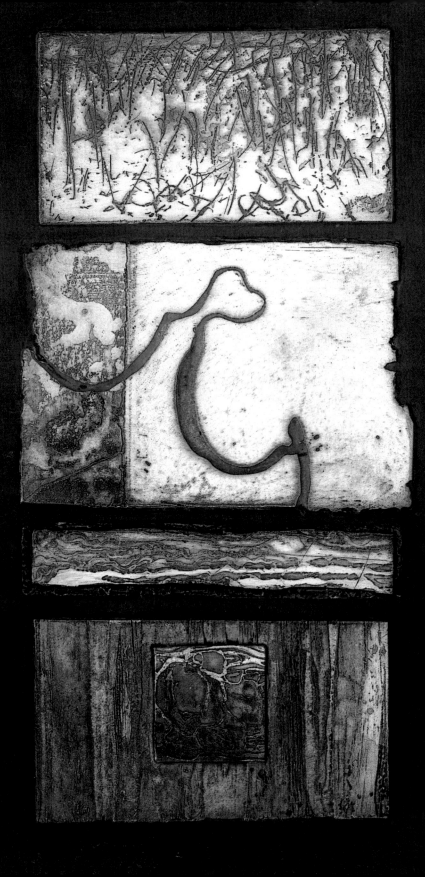

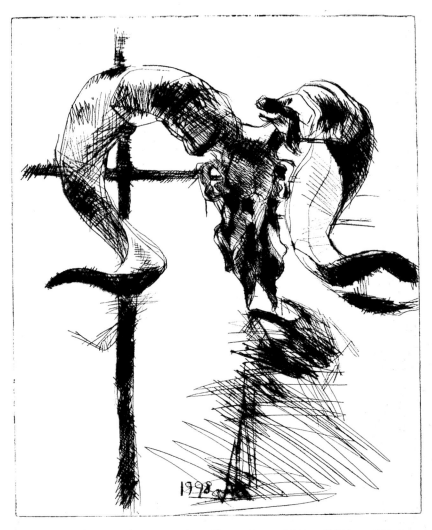

Above: 'Ram's Skull', drypoint by John Sellings, 29 cm x 24.7 cm (11½ in. x 9¾ in.).
Drypoint made by drawing directly from the object onto a copper plate.

Left: 'Elemental Icon 1', etching/collagraph by Brenda Hartill,
50.8 cm x 40.6 cm (20 in. x 16 in.).
Known for her sculptural approach to etching, Brenda Hartill bites her plates
to several deep levels using very strong acid and prints them on heavy papers.
Her 'Elemental Icon' series is based on the dramatic formations, weather and
light of the wild mountains of Spain.

gently into the lines with the fingertip, to check on progress. Of course, the image on the plate will be in reverse until printed.

Even with the burr worn away, a line will remain which will hold ink and therefore will print, although the line quality will be very different from the original drypoint line. This variation in line quality can be capitalised upon within your image by gently scraping the burr away (using a scraper or burnisher), and the resulting printed line will be pale and silvery. You may find this contrast useful in creating distance or emphasis within the image, with the foreground being the blackest of drypoint lines, in contrast to the paler (de-burred) drawing of the background.

Drypoint materials

There are some good non-metal materials on the market for making drypoints, such as plastic sheets (Perspex) from glaziers, or thin, coated card from some printmaking suppliers. An even cheaper alternative is to make your own drypoint 'plates' by coating a piece of mounting board, or much thinner card, with thinned-down PVA to seal it. When dry, make your image onto this with a drypoint needle, coating any deeply scratched areas with the same thinned-down PVA.

Zinc is rather a soft metal for making drypoints and the burr will wear down after only a few prints; however, it is an excellent metal to start with.

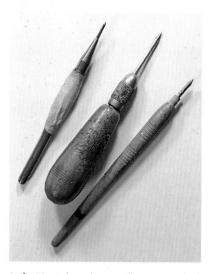

Left: Most drypoint needles are made from steel and some have diamond tips. Preferably, they should be heavy in weight and kept very sharp. My personal favourite is Nick Ward's invention of a pristinely sharpened 'OBO' nail (left, centre), sunken into a handle or wrapped generously in masking tape to make it more comfortable in the hand.

Right: Essential etching equipment: needle/burnisher and scraper.

Copper is harder and therefore better for drypoints and it can be steel-faced, once the image is made, to harden the surface still further.

Drypoint methods

Make your drawing using firm pressure; the tool should be held in an upright position like holding a pen. Use a range of line techniques such as cross-hatching for building up strong black areas. If printing from drypoint card, a bevelled etching plate can be laid on the press bed first to avoid drastic readjustments to the pressure of the etching press.

Etching

An etching is any form of intaglio process where the image is bitten or corroded into the plate by some form of mordant (acid or corrosive salt). The most popular metals used in etching are zinc and copper, but steel and iron can also be used. Most people begin with zinc, which is relatively inexpensive and etches extremely well. The most common method of making an etching is with hard and soft ground techniques, where a drawing is made through a layer of wax which acts as an acid resist. The exposed metal of the drawing is then bitten by the mordant.

'Butterflies II', etching by Nerys Johnson,
16.4 cm x 6.2 cm (6½ in. x 2½ in.).
With severe restriction of movement, artist Nerys Johnson believed etching to be beyond her physical capabilities. However, in the 1970's, tutor Chris Penny suggested to her that she drew onto the plate, through soft ground, using a dry point needle. The heavy weight of the tool, resting between thumb and forefinger, penetrated the ground easily without undue pressure, leaving her free to draw the image. This delicate print was made in a single biting.

Methods such as drypoint, engraving and mezzotint do not involve a mordant, and are therefore not classed as etchings; but they are printed in the same way and are therefore all intaglio processes.

Hard-ground etching

This type of ground is laid thinly onto a heated metal plate and when cold, the image can be drawn through it with any sharp implement. It is not necessary to draw with any great force, as it will be the action of the mordant that will give the depth of line required to make a print. Traditionally, the tool for drawing into a hard ground is known as an etching 'needle', but it is worth experimenting with a variety of sharp metal points for a range of line qualities. A roulette is a spiky wheel used to build up 'tonal' areas by making a series of tiny indentations through the hard ground.

Depth of bitten line denotes strength of printed line – i.e., the deeper the biting, the more ink it will hold and the darker it will print. See 'Biting the plate' on p. 59. The temperature of the hotplate has to be fairly high to melt and lay the hard ground onto the plate. See section on laying the ground, p. 52.

Drawing a complicated image through a hard ground can sometimes take days and it is likely that there will be a build-up of grease from your hands. This may partially block the drawn lines, preventing them from biting. De-greasing the drawn plate, prior to placing it into the mordant, will ensure accurate biting. See 'De-greasing the plate' on p. 52.

'Waiting', aquatint by Jane Stobart, 22 cm x 12 cm (8⅝ in. x 4⅝ in.). Coarse aquatint (applied by jar method) with white area 'stopped out' prior to biting.

Liquid ground

If you do not possess a hotplate, liquid hard ground is available. Place your de-greased etching plate in a shallow dish, tipped at an angle, and pour liquid ground over the plate. The excess can then be poured back into the container. Leave plate to dry overnight.

Soft-ground etching

Soft ground contains tallow, as well as wax, causing it to remain soft and impressionable, even when cold. The two grounds can be

easily identified in their cake form (unlaid) as you can sink your nail into the soft ground, but not into the hard. Wax-based furniture polish is a good substitute and cheaper than etching ground. I found that freshly laid wax polish makes an excellent soft ground, but a day later, it sets to form a hard ground.

A recently laid soft ground can be penetrated by anything that is pushed into it, such as lace, netting, the veins of a leaf, etc. It will also give you a wonderful line if you draw onto the plate through smooth, thin tissue paper, placed lightly over the soft-grounded plate. When drawing firmly with a pencil such as a '2B' onto the tissue, the ground will stick to the paper and be removed when the tissue is peeled away. The quality of the bitten line will have the grainy quality of the pencil.

Planning the image

A drawing or tracing made with a soft pencil can be offset onto a hard-grounded plate, as a drawing guide, by simply rolling them through the press together (having reduced the pressure). Place the tracing face-down onto your plate so that it transfers in reverse, then the image will right itself when printed. *Always* file your plate edges before rolling it through an etching press; otherwise the plate may cut through the blankets.

Above: The three hatched areas at the top of this print were drawn through a hard ground and bitten for 10, 20 and 40 minutes respectively. Biting times are accumulative, so the darkest has actually bitten for a total of 70 minutes (10 plus 20 plus 40). The plate was removed from the mordant after each biting, rinsed, dried and one of the areas stopped-out. Secondly, the plate was cleaned and a soft ground layed onto it. Lace, a leaf, card and sponge, etc., were pressed into the ground and the plate was deeply bitten. The section in the centre was drawn onto soft ground through tissue paper, using a soft pencil.

Left: Separate leather dabbers (or grounding rollers) are used for laying hard and soft grounds. Due to the high grease content of one and the grease-free nature of the other, ensure they are never accidentally interchanged by marking handles with a large H and S. Hang up, when not in use, to avoid picking up grit.

If planning a soft-ground etching, a drawn guide can be worked out in advance on tracing paper; place lightly on top of the grounded plate (remembering to reverse your tracing) and slip a piece of tissue paper between the two. Drawing with a ballpoint pen onto the tracing paper will ensure that the tissue underneath receives enough pressure to remove the soft ground.

De-greasing the plate

This is necessary if you are laying a hard ground or aquatint, but not for a soft ground, which contains grease already. You can concoct an excellent de-greasing agent from three tablespoons of salt in a pint of vinegar. Put the solution into a spray bottle, then shake and spray over the entire plate area; rinse with water. If your plate is de-greased properly, water should run freely over it, unimpeded by greasy areas. If you have recently used white spirit, etc., wash the plate first in washing-up liquid.

'Foul biting' (rogue dots penetrated by the mordant) can occur if any salt is allowed to dry on the plate; rinse off the salt and vinegar solution very thoroughly straight after its application.

Laying hard and soft grounds

1. Place the de-greased plate between clean sheets of newsprint paper, blotting until completely dry – back and front. Never dry the wet plate directly on the hotplate, which will cause it to buckle.

2. Unless using liquid ground, you will need some form of hotplate for laying a ground (see section on 'Hotplates', p. 54). Wipe hotplate thoroughly before use to remove any dust, etc. The etching plate should be heated enough for the cake of ground to melt on contact. The heat required to melt a hard ground will be greater than for melting a soft ground.

3. Melt a few 'scribbles' of either ground onto the heated zinc, copper or steel plate.

4. Dab (or roll) the ground out firmly all over the plate surface; aim for a thin and even coating which should look reddish-brown in colour. If your wax coating looks dark brown, it is probably too thick, so clean your dabber or roller by wiping it onto a piece of clean acid-free tissue (on the hotplate), then dab or roll again. This will reduce the amount of wax on the plate.

5. Remove plate from the hotplate by sliding a palette knife underneath and placing the plate somewhere clean, to cool down.

Many etchers like to smoke the grounded side of the plate with tapers, making it much darker for tracing and drawing onto, but this is not

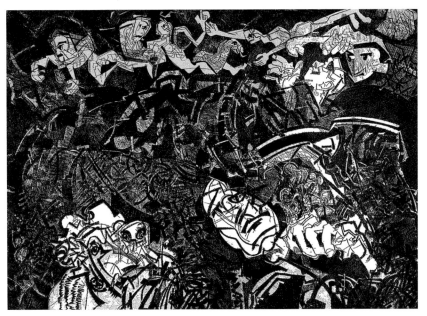

'At Loggerheads', etching by John Grigsby, 42.4 cm x 59.2 cm (16¾ in. x 23¼ in.). Hard-ground etching built up by a series of bitings. The plate was re-grounded, re-drawn and re-bitten many times over, resulting in a dense and complex linear image.

absolutely necessary. Draw through the ground, as described earlier, and bite the plate.

Re-grounding the plate

You may wish to re-ground the plate for further drawing and biting. De-grease your plate and heat again, melting on the ground and rubbing it into the previously bitten lines using a small square of clean scrim or any clean, lint-free cotton rag. Apply more ground and dab or roll the surface as before. This will ensure that previously bitten lines do not remain exposed and bite still further.

Alternative methods

Stopping-out varnish can be used directly onto an etching plate, instead of a hard or soft ground.

Most wax-based materials will act as acid resists; this print shows the effect of (i) litho chalk (ii) lithographic tusche, melted and water added (or litho drawing ink) (iii) chinagraph pencil. The aquatint background was bitten for 15 minutes.

'Ponte Rotto No. 2', etching by Paul Hawdon, 49 cm x 64.5 cm (19¼ in. x 25½ in.).
No etching grounds were used in the making of this print; stopping-out varnish
alone was painted on to retain the white areas of the image and there are
several levels of deeply bitten plate.

Shellac can be substituted for stopping-out varnish; this is removed using
methylated spirits.

Some printmaking suppliers sell acid-resist pens for making lines and
patterns; useful for drawing over areas of fused aquatint.

Chinagraph pencil, lithographic chalks, tusche and liquid litho drawing
ink all make excellent acid resists. Anything waxy is worth trying. See test
print on p. 53.

There are some special acrylic-based etching grounds and stop-out
systems available from some printmaking suppliers. I did not get on at
all well with these products and have found more success using straight
acrylic paint. Courses are advertised in some printmaking and artists'
journals specifically for acrylic-based etching techniques and non-toxic
printmaking methods.

Hotplates

There are various electric hotplates on the market, designed for etching,
and you should look for the sturdiest that you can afford. I use a 'hot table'
which is an all-metal affair, made by a printmaking engineer, which I heat
with a camping stove or equivalent underneath. Make sure you have a
strong bench for your hotplate to stand on; mine has a fire-retardant sheet
underneath, as I use an open flame.

A steel sheet can be placed over a cooking hob, but it must be a stable fit, as the motion of putting on a ground may damage your cooker.

Aquatints

Beautiful tonal effects can be achieved by fusing a sprinkling of resin dust onto a metal plate and biting around the particles; this is known as an aquatint. Traditionally made from powdered resin (rosin) or bitumen, aquatint is applied in an aquatint box or 'dust box'. This is a tall, enclosed container, housing a liberal amount of fine powdered resin, which is thrown into the air (inside) by fan or bellows. The plate is then placed inside the box and the particles of dust settle onto it.

Like most airborne powders, resin is hazardous to the lungs, and it is vital that you wear a suitable mask when laying it either by the box method or the hand-thrown method (explained later). If you are put off by the potential risks to health, you should consider using the acrylic screen-filler method also outlined later in this chapter.

Laying a traditional aquatint

1. De-grease your metal plate and dry thoroughly between sheets of clean newsprint paper.

2. Place plate onto a grill (such as a barbeque grill) with a piece of stiff paper or card underneath, to avoid an up-draught disturbing the resin around the edges of the plate.

'Return to Worthing', aquatint by Harry Eccleston, 25.6 cm x 34.5 cm (10 in. x 13½ in.).
The aquatint used here is so fine that it looks like a watercolour wash. This could not be achieved without an aquatint box.

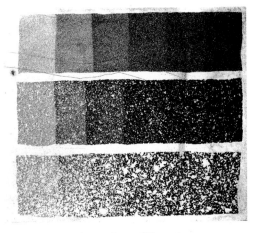

This test print shows three different aquatint grounds (from top to bottom): **1**. fine-resin aquatint – layed with aquatint box, **2**. medium-resin aquatint – layed with the coffee-jar method, **3**. coarse-aquatint – made by flicking water-based screen-filler onto the de-greased plate with a stiff brush. The biting times for all three were: ½ min.; 1 min.; 2 mins; 4 mins; 8 mins; 16 mins – final biting for each is therefore 31½ mins (½ plus 1 plus 2 plus 4 plus 8 plus 16).

3. Rotate the external winding handle 40 times, rapidly; this turns an internal 'blade', sweeping the dust into the uppermost part of the box. Fix the handle into its locking device which also fixes the 'blade' inside to a horizontal shelf, where your plate will sit to receive the aquatint. If using a home-made aquatint box, shake the box up and down about ten times, then set it down. It's difficult to measure the amount of resin in my own aquatint box, but it sits thickly on all internal surfaces.

4. You can control the grade of aquatint (medium-fine to very fine) by timing the delay in placing the plate inside the box. This controls the amount of powder landing on it. Waiting ten seconds or a full minute before entering the plate will make a huge difference.

5. Place grill inside the box for four minutes.

6. Remove plate with great care and repeat the whole process of winding and waiting for a second time. Repeat this procedure a third time if your aquatint is to be extremely fine (if you are delaying entry for one-minute plus).

7. After the final time in the aquatint box, metal should be only just visible. Carefully remove the stiff paper from underneath plate before fusing the aquatint.

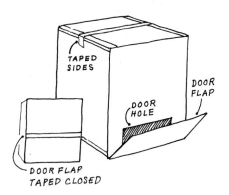

TAPED SIDES

DOOR FLAP

DOOR HOLE

DOOR FLAP TAPED CLOSED

Take a large, sturdy cardboard box, cover all ajoining flaps (inside and out) with parcel tape to completely seal; cut a door as shown. Stick larger false door over the cut hole and secure this firmly with draughting tape before shaking, to avoid escaping resin. 'Draughting' tape is low-tac and will not tear the card surface so readily when opening and sealing door. Place fine, powdered resin inside and use an old barbeque or toaster-grill to place plate into box. A mask should be worn.

Fusing the aquatint

Heating up the plate to the correct temperature will melt each particle of powder separately. Overheating results in the resin particles spreading together like toffee; under-fusing causes the particles to float away in the mordant. Resin turns transparent when fused.

Hotplate method – If using a hotplate, place your plate directly onto the heated surface. You will need to have a flat-ended palette knife to move the plate around into the hotspots and to then remove it quickly when fusion has taken place all over.

Open-flame method – I fuse my plates with a methylated-spirit kettle stove, rotating the grill in the flame to get the plate to heat up

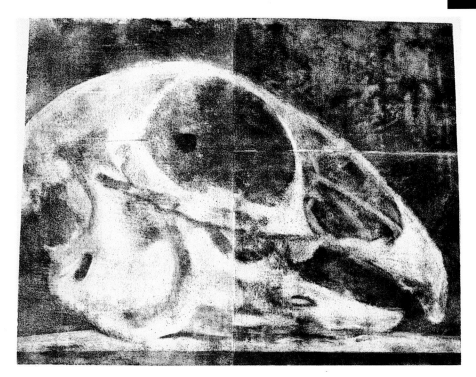

'Corvo', aquatint by Peter Freeth RA, 48.5 cm x 63.5 cm (19 in. x 25 in.).
Printmaking is open to much invention. Peter Freeth's prints' often start life as
a monotype, carried out on an etching plate. The image is then sprinkled with
powdered resin, and when tapped, sticks only to the wet ink. The plate is then
fused and bitten as for a regular aquatint. The ink underneath does not appear
to prevent the plate from biting.

evenly. The centre of the plate tends to absorb the heat rapidly, so concentrate on the edges, taking care not to dwell in any one place. When resin starts to turn transparent, take care not to overheat; move rapidly to unfused areas.

Laying aquatints with a coffee jar

Although an aquatint box can be an expensive item of equipment, inexpensive substitutes can be made. I rely more and more on a coffee-jar method to apply resin aquatints.

A medium-size jar is ideal for laying 'hand-thrown' aquatints. Discard the lid and fill about a quarter-full with powdered resin and then place two layers of scrim and three or four layers of nylon tights over the top of the jar. Bind these layers tightly with string or rubber bands and pull the material down hard underneath, eliminating any slackness. Cut off string-ends below the knot to avoid these disturbing your aquatint layer.

Wearing a mask, smack the jar base – sprinkling resin evenly over the de-greased plate, until the metal colour is barely visible. Fuse as before.

'Tired Runabout', etching and aquatint by Nicholas Ward, 15.2 cm x 10.9 cm (6 in. x 4¼ in.). Nick's great love of motorbikes has led to a series of interesting prints. Firstly he places his various bikes into giant still-life set-ups around his house or garden. Then he makes several detailed drawings which form the basis of his etchings.

Removing resin after biting

The fused resin will need to be removed from the plate after biting and before proofing. It will dissolve totally in methylated spirits.

Aquatints with screen-filler

'Hunt Speedball' screen-filler is a non-toxic alternative to aquatint dust. It is an acrylic-based, brick-red liquid that acts as an acid resist. Watered down a little, this can be airbrushed onto a de-greased etching plate as finely or as coarsely as required – coarseness being a heavier build-up of spray. For a really coarse texture, prop up your etching plate (backed liberally with newspaper) and flick the screen-filler onto it by running your finger across a stiff brush or toothbrush loaded with filler. Remove filler after biting by soaking in hot, soapy water and scrubbing with an old washing-up brush.

Alternative aquatint methods

Liquid aquatint grounds can be obtained from printmaking suppliers, which are made up of resin dissolved in alcohol. This does away with the need for a dust box altogether, but the drying time is about 24 hours. Follow the manufacturer's instructions.

The salt-grain method was introduced to me by Irvine Loudon. Firstly, lay a thin, hard ground onto your de-greased plate. Place the still warm plate onto a sheet of newspaper and cover immediately with a thick layer of table salt. Lift the plate onto its side and tap it gently. Most of the salt will fall off, but a thin sprinkling will be left, stuck to the ground.

Heat the plate to a very high temperature on the hotplate until the ground liquifies; the salt will then sink and is brought into contact with the plate itself. When the plate produces a wisp of smoke, remove from the heat source. Place cooled plate in a dish of lukewarm water, which will dissolve each grain of salt, thus exposing an aquatint texture on the plate.

'Lift' grounds

A 'lift' ground enables you to paint positive marks onto the plate which, when aquatinted, become the bitten parts of the image. The best known of these is called 'sugar lift', which is a saturated sugar solution containing

some soap and a little paint, to give it a definite colour. Sugar-lift solution can be bought from print-making suppliers. White gouache paint used thickly also works well and can be used straight from the tube (see right).

Etching the plate

Protecting back of plate

The back and sides of the plate will need to be protected before placing in any mordant. Traditionally stopping-out varnish is used, but parcel tape (light brown in colour; shiny finish; very sticky; usually 5 cm/2 in. wide) makes an excellent alternative when stuck firmly onto the back of the plate. Shellac varnish will also resist the mordant and is removed with methylated spirits. Etching plates can be bought with a permanent acid-resistant coating on the reverse side. If the coating develops scratches, tape them over.

'Dan', lift-ground aquatint by Jane Stobart, 9.2 cm x 6.5 cm (3½ in. x 2½ in.). Thick, white gouache is painted onto a de-greased plate where you wish to bite. When dry, the entire surface of the plate is covered with thinned stopping-out varnish (add white spirit and mix thoroughly). When dry, soak plate in hot water until the paint (underneath the 'stop-out') begins to show. Coax off with a brush or finger until the bare metal is exposed where the paint was. De-grease plate once more and lay aquatint over the entire plate (stopped-out areas as well). Fuse and bite as usual.

Biting the plate with ferric chloride

Many etchers are turning to ferric chloride, which is not an acid at all, but a corrosive salt and therefore less hazardous than acid mordants. 'Biting' with ferric chloride produces carbon dioxide with copper and hydrogen with zinc and does not therefore need to be used in a fume cupboard or extraction booth; it can be used safely in the home with nothing more than good general ventilation.

Biting zinc

Zinc will form bubbles of hydrogen as it bites in ferric chloride, which need to be brushed away as they form with a stiff goose feather. The tray also requires rocking occasionally, to wash out the sediment that forms in the lines.

INTAGLIO PRINTING

Biting copper

When biting copper plates, no feathering is necessary but the tray should be regularly rocked (to wash out the sediment), just as you would with a photographic developing tray. Both zinc and copper will 'bite' accurately with no widening of the lines, as happens with nitric acid. Keep solutions for zinc and copper bottled up separately and well labelled. Make a test plate to gauge biting times for hard-ground line, soft-ground line and aquatint.

Biting times are affected by temperature, so plates will bite much slower in winter than in summer, therefore never etch in a freezing room.

'India Portfolio', etching by Vijay Kumar (USA), 30.5 cm x 40.6 cm (12 in. x 16 in.). This aquatint was made on a copper plate by the spit-biting method, where ferric chloride is painted directly onto an aquatint with soft watercolour brushes. If the mordant will not lie directly on the metal surface, it can be held in desired area with saliva or as in this case, gum arabic.

Biting the aquatint

A fused resin aquatint will be transparent and you will therefore see any previously bitten work underneath, which is useful as a guide for stopping-out as you bite. Alternatively, a drawing can be traced down onto a fused aquatint through carbonless transfer paper, or by chalking the front side of the tracing, then re-drawing it down in reverse. It is quite difficult to see the chalk impression, but an with angled lamp it is just possible. Carbon paper is better still, but will resist the acid if allowed onto the metal. The aquatint is delicate, so care should be taken not to scratch it off or crush it by tracing down too severely.

It is likely that you will bite the aquatint to different depths, creating a number of tones; initially any areas to remain white should be stopped-out before the plate is etched. After this first biting, stop-out next lightest areas and re-bite, doubling-up the time with each biting (see test print on p. 55).

Mixing the ferric chloride solution

Most students etching at an evening class soon realise the advantage of having a bottle of dilute ferric chloride and a biting tray of their own. In this way you can be fairly sure of the strength of the mordant, which swiftly loses power in a group situation.

- I find liquid ferric chloride better than the crystal form. The strength should be 45° baume (sometimes called ferric chloride 'strong').

- The popular dilution ratio is 1-part ferric chloride to 2-parts water, but if you find this too slow to bite, try 1:1. *ALWAYS* add the ferric to the water, as with any type of acid. You should wear gloves, an overall and goggles for this operation.

'Window Series no. 1', by Jacquie Newell, 45.5 cm x 33 cm (18 in. x 13 in.). Aquatint, using lithographic liquid tusche as a resist (see p. 93).

- Store diluted solution in a dark glass jar as with other mordants. A friend of mine got an excellent, big, dark glass jar from her local pharmacist.

- When your solution is past its useful life, it will appear cloudy and at this stage it is time to make a fresh mix. The old solution can be washed down the sink with the blessing of the Environmental Health Department. Apparently, it is used in the sewage treatment process.

Buying ferric chloride

Dilute ferric chloride can be bought from some electrical wholesalers as it is used to etch circuit boards, strength 1:1. It can also be obtained neat from some industrial chemical suppliers and certain printmaking suppliers. Glass or enamel oven dishes or cat-litter trays make excellent and inexpensive biting and rinsing trays.

Be warned that although this mordant is safer than acid, ceramic sinks, clothes, acid trays, feathers, etc., will all turn orange. The stain can be removed from sinks with a scouring cream and does not seem to penetrate very deeply. However, clothes are stained permanently.

Rinsing the plate after biting

When removing your plate from the ferric chloride, drain it over the biting tray and then wash thoroughly under running water. I place mine in a dish containing cold water first and then rinse it with a watering-can in the garden.

Printing the plate

Before printing, remove grounds, stop-out varnish, aquatint, backing tape.

Bevelling the edges

Plate edges will need to be bevelled prior to printing, to avoid cutting through the expensive etching blankets on the press. File edges to about 45°, in a specially chosen area, well away from the hotplate or press. Metal filings can scratch the plate if caught up by the grounding dabber or allowed to stray into the printing ink.

Norfolk printmaker Nick Ward designed this small, simple etching press in association with an engineer. Like all the best presses, it is of all steel construction for maximum strength and rigidity.

Getting a true print

To get a 'true' print (one that shows an accurate picture of the work carried out so far), there are three main things to consider:

- The paper will need to be correctly dampened, not too wet and not too dry.

- The printing ink should be of the correct viscosity (consistency) for printing.

- The pressure of the press should be correct for the guage of metal to be printed.

Preparation of paper

The paper should be thoroughly dampened in order to be forced into the depths of the inked intaglio plate as it rolls through the press. The heavier-weight etching papers such as 300 gsm Somerset, Bockingford or Arches or other 'sized' papers can be soaked in the bath of cold water overnight. If in a hurry, 30 to 60 minutes in warm to hot water will be enough time to soak the same heavy-weight papers. These are all excellent for intaglio printing, but there are cheaper alternatives. Cartridge paper (soaked for about two minutes) is certainly an adequte substitute; but nothing thinner than that.

Lift the paper out of the bath and drain it, then place each sheet separately between clean sheets of thick blotting paper (this can be used over and over again, so long as you dry it thoroughly after use). It is important not to let the paper dry out, so house all of the blotters between two sheets of polythene (portfolio sleeves are ideal). Place a weight on top, such as a drawing board, and allow to stand for at least an hour. By the time you take a print the paper should be still totally damp, but with no surface water visible on either side.

'Three Bells', by Jane Stobart, 36.5 cm x 26.7 cm (14.5 in. x 10.5 in.). Soft-ground drawing and coarse aquatint, layed by coffee-jar method. Bell highlights were created by scraping and burnishing.

Viscosity of ink

There are some good intaglio inks on the market and lithographic printing ink is also used by some etchers. In my experience, most intaglio inks are improved by a tiny amount of medium copperplate oil thoroughly mixed in. Inks straight from the tube or tin tend to print a little too dry and do not give a true and accurate print. Aim for a soft, glossy consistency, which will drop very slowly from the palette knife – not run off (too much oil) and not stay stubbornly put (too little oil). Ink that is mixed to a specific colour or consistency can be kept for quite a while in a double layer of food wrapping film. To cut down on the ink skin that forms in the tin, cover exposed areas with plastic food wrap.

Setting the pressure of the press

Before inking-up, check the pressure of the press by running an un-inked, bevelled plate through the press with a piece of damp paper or dry blotting paper. The plate should show through the reverse side of the paper as a sharp and evenly embossed shape. By doing this you can often detect uneven pressure. Adjust the pressure bolts on each side of the press if necessary. If creases occur on one side of the paper, loosen pressure slightly on the creased side.

Using the press

I usually have three blankets on my press – two fronting blankets first (thinner, compressed) and one swanskin on top (fluffier, thicker). Nick Ward suggests four layers of woollen 'army' blanket (available from army surplus stores) as a much less expensive option. It is important to keep your blankets as clean and soft as possible. After a while, they will become stiff through the absorption of size from the damp paper and will need to be washed. Because they are already shrunken to make them compact, blankets can be washed in a washing machine. Dry over a banister rail, with a towel underneath, to avoid making an impression on the blankets. I always have a piece of blotting paper placed on the bed of my own press, onto which I place the warm, inked plate. Put dampened paper on top and carefully pull the blankets over the paper so that they are taut. Run the bed through the press.

Always peel the paper slowly from the plate after printing to avoid it sticking to the ink.

Inking-up

You can print your plate without the use of a hotplate, but some printmakers believe they get a greater tonal range by heating the plate slightly when inking-up. Only a gentle warmth is required or the ink will dry in the lines. You can get inking dabbers or inking rollers, but a supply of stiff card pieces (mounting-board weight) cut to 5 cm x 7.5 cm

(1 in. x 2 in.) can also be used to squeegee the ink across the plate. This is inexpensive (ask your local framer for card off-cuts) and uses far less ink. You can purchase a rubber squeegee especially for intaglio printing, but this will blunt after a while.

1. Mix ink thoroughly with a few drops of medium copperplate oil to a glossy consistency.

2. Warm plate (if possible) and squeegee the ink firmly across the *entire* plate surface (regardless of where image is bitten). Hotplate should be warm – not too hot or the ink will dry on the plate.

3. Take up scrim and make a smooth ball in the hand by folding all loose edges inward.

4. Wipe ink from edges into the centre of plate, using firm, flat movement to drive the ink into the recesses of bitten image.

5. Re-fold scrim to cleaner area when necessary (or swap to cleaner piece of scrim), and continue wiping until plate is clean of surface ink.

6. For a really clean print, give a final wipe with the side of your palm – or not, if you wish for a surface plate tone. Rub a little whiting into your hand to dry ink residue when necessary. Small pieces of tissue paper under index finger can also be used to polish off any surface ink.

7. Wipe ink from bevelled edges of plate with a rag-covered finger.

8. Plate is now ready to print; leave plate on the warm hotplate until ready to transfer to press.

Relief inking of plate

Another colour can be introduced by rolling ink over the entire surface of the wiped plate, as you would for a linocut. Having inked-up your plate and wiped as normal (intaglio), cool the plate and then roll over the top of the plate (relief) with an additional colour.

'Results of Action II', by Olga Sankey (Australia), 62.5 cm x 43 cm (24.6 in. x 16.9 in.).
Three colour etching on tin, bitten with nitric acid. The plate was cut in to two sections and inked in relief (as for a linocut), then reassembled for printing on slightly dampened Japanese *Honomura* paper. The small shape on the red section was applied by rolling through a mask with a stiff purplish-brown ink, prior to rolling over the entire shape with an oilier red ink; the difference in viscosity caused no disturbance to the first colour laid down.

'Concert by the Sea', by Karolina Larusdöttir, 30.5 cm x 39.2 cm (12 in. x 15½ in.).
This one-plate print has several inks applied 'locally' – with small pieces of card,
small balls of scrim or cotton buds. Wiping the plate is carried out tactically, to
keep each colour from merging with the surrounding colours. Small pieces of
tissue can be used under the index finger for final wiping of small areas.
Printed by Linda Richardson.

The ink layer needs to be incredibly thin or a texture will be apparent on
the print. Recently, a student of mine drew into the relief-rolled ink with a
rag-covered finger (as for a montype) to create a unique effect.

Local colour

Several colours of ink can be applied to the plate, with small balls of scrim,
cotton buds or thin card squeegees. Wiping is tricky but possible, using a
piece of scrim for each separate colour and wiping in small circular
motions. An overlap of colours is inevitable, but this blend will harmonise
the overall effect.

Chine collé

Thin, coloured papers or tissues can be laid down onto an inked plate,
before the damp printing paper is placed on top, to create a collage under
the intaglio print. The chine collé paper/s must be coated with some kind
of glue (on the side that will meet the printing paper) to create a bond.
There are several pastes on the market that are acid-free (p/h neutral) and
will not discolour over time; some are in powder form and others are

already mixed. Acrylic matt medium is also an excellent adhesive. The glues you can buy in the stick form (from any High Street stationers) are also virtually p/h neutral. This technique can also be used in relief printmaking. See prints on pages 9 and 26.

Refining the image

Using the burnisher and scraper

These tools are a vital part of your intaglio printmaking equipment. They are used for removing or lightening lines and areas of aquatint. I bite my aquatints to a dark tone and then work back to lighter areas or white, using either the scraper or the burnisher (the printmaker's equivalent of using an eraser). See illustrations on pages 63 and 67. The sharp edge of a scraper will cut through the metal, shaving it away. The burnisher is used for gently rubbing down the metal or introducing highlights.

Hold the burnisher and scraper very flat (about 5° to the surface of the plate). Scrapers are used dry, but when burnishing, cover the relevant area of plate with a film of thin bicycle oil and gently but firmly burnish the area to be lightened.

Flattening prints

There are two ways of flattening intaglio prints:

1. Place damp print on wooden board and stick dampened gum-strip around all edges. As the paper and gum-strip dry, the print will stretch flat. You can carry out this method immediately after printing, or soak print in bath at a later date and then stretch. When completely dry, cut print from board.

2. This slow, flattening process takes about four days. As you pull each print, place between

'*Newham's Cathedral of Sewage II*', *by Jane Stobart, 26 cm x 19.4 cm (10¼ in. x 7.5 in.).*
A coarse aquatint (hand-thrown, by coffee-jar method) was bitten all over this plate and then the image gradually burnished back.

clean, dry sheets of blotting paper. House between polythene sheets and weight down with heavy board. Change blotters daily until your prints are dry and flattened. To keep your blotters clean, a piece of acid-free tissue can be placed on top of each print first.

Cleaning up after printing and storing plates

See section on solvents at end of Chapter Two.

Having removed every trace of ink from the plate and dried it thoroughly, you may like to place on a warm hotplate to thoroughly dry before wrapping in a couple of sheets of acid-free tissue. Zinc will oxidise if the plate is stored damp, which will penetrate the surface of the metal and print. Place upright in a dry place for storage. If storing plates longterm, they can be given a coat of stopping-out varnish on the image side and wrapped in tissue when dry.

'Memory of Experience', aquatint and screenprint by Sacha Bela Nixon (Australia), 56.5 cm x 41.7 cm (22¼ in. x 16¼ in.).
The head image was created by two aquatints – firstly a coarse one, deeply bitten and then a finer one on top, bitten for less time. The soft edge of the aquatint shape was made when inking-up, by teasing ink from the aquatinted area into the white shape with a soft piece of the scrim/tarlatan. The gold details were screenprinted on top of the print, using acrylic ink.

Chapter 5
COLLAGRAPH

There has been a great deal of interest and excitement about collagraphs in the last few years. This relatively new method of printmaking uses a variety of textured materials stuck onto a cardboard base to create a low relief block which is inked-up like an intaglio plate and printed on an etching press. There is much room for invention here, as long as certain principles are understood regarding the printing process.

'The Dance of the Fairy Elephants', by Deanie Wellings, size unknown.
Print taken from collaged block of flan cases, ephemera, silver card and incised lines.

Top: *Jacquie Atkinson's matrix.*
Card block constructed with areas of coarse and medium-grade sandpaper, toilet paper moulded into ridges with PVA glue and a sky of coarse sugar.

Above: *'Rochas – Buzio', by Jacquie Atkinson, 23.5 cm x 24 cm (9¼ in. x 9½ in.).*

The ideal height of the collaged elements should be no higher than the thickness of the base-board.

Constructing the block

The collagraph block can be made up of materials as diverse as scouring pads, anaglypta or wood-chip wallpaper, wool, seaweed, textured fabrics such as linen, corduroy and hessian, corrugated card, netting, string, bubble wrap, paper doilies, carborundum powder, PVA glue and acrylic texture paste. *Never* use coins, wire or anything metal, as it will damage the rollers of the printing press.

The ideal block height

There must be a limit to the overall height of the relief block you create. The ideal base-board thickness is a sheet of mounting board or the back cover of a sketchbook. The maximum height you build onto this should be to about the same thickness again. Hugely differing heights will not print evenly as there is obviously a limit to the capacity of the printing paper to mould itself into very deep recesses without tearing.

Sealing the collagraph

All of the collaged elements should be stuck onto the base with PVA glue and allowed to dry thoroughly overnight. The relief block may need levelling slightly and running it through the press a few times un-inked will sort this out. Finally, button polish or knotting varnish (both shellac-based) should be painted liberally onto the block and allowed to dry. Paint the reverse side of the collagraph also, so that you can clean freely after printing. Allow varnish to dry thoroughly.

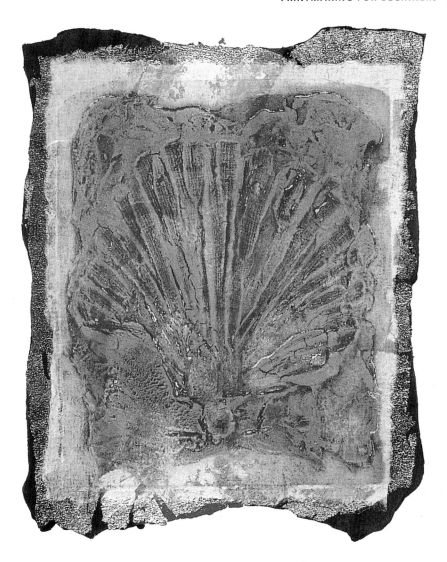

'Coquille', by Barbara Munns, 50.5 cm x 41 cm (20 in. x 16¼ in.).
The shell image in this collagraph was printed from a metal plate, onto which a mixture of acrylic paste and fine carborundum powder was applied. An impression of a shell was made into this and allowed to dry. The base colour of the print was first laid down by stencil; metal and silver leaf were applied to this using size. The paper was dampened and a thin sheet of glued paper (chine collé) was laid over the inked plate; this became attached during the intaglio printing of the shell image.

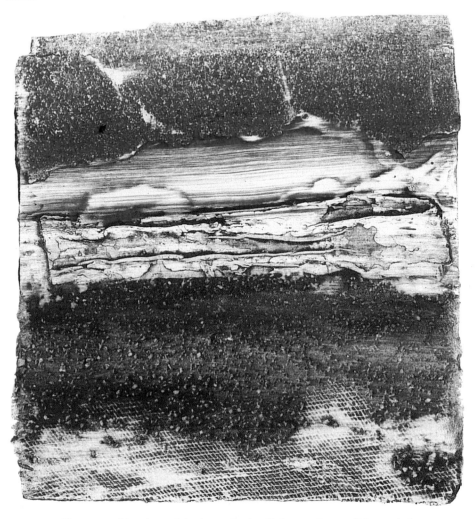

'Fragment of Landscape', by James Beale, 12.6 cm x 10.1 cm (5 in. x 4 in.).
The materials used in this collagraph block are string, corrugated paper, glue,
sandpaper, and carborundum grit. The prepared block was thoroughly coated
with shellac and printed on dampened 300 gsm Somerset paper.

Inking-up

The inks most suitable for printing collagraphs are those designed for
intaglio printmaking. These can be quite stiff straight from the tube or tin,
but a little linseed or medium copperplate oil thoroughly mixed in will
make application to the block much easier.

There are two distinct areas to consider inking; firstly the lower
'intaglio' levels of the block, which need to have ink forced down into
them with a toothbrush or small scrunched-up balls of scrim. Ink should

be wiped from the surface of the block with scrim, as for intaglio printing, so that it is held in the lower levels only. Secondly, the uppermost 'relief' levels can be inked with rollers, fingers, or more scrim balls.

The intaglio and relief levels of the block can be 'locally' inked with a variety of colours in selected areas; apply separately with pieces of scrim, small rollers, etc. Highlights can be created by wiping the ink from the surface with tissue or newspaper.

Preparation of paper

As with intaglio printmaking, the paper will need to be damp in order to mould itself into the many levels of the collagraph block. Dry paper would not be flexible enough to do this and would crease under the pressure of printing.

Suitable papers for printing collagraphs are smooth etching or smooth watercolour papers, which are classified by the initials 'HP' (Hot Press). The ideal weight is 190 to 300 gsm, but proofs can be taken from thinner paper such as dampened cartridge.

Prepare paper as for intaglio printing (see p. 63), but without such an intense period of soaking, as this can cause the surface of the paper to stick to the inked block; soak cartridge for a few seconds and heavier papers for ten minutes before blotting thoroughly. No surface water should be visible on the paper by the time you take a print.

Peel the print from the block slowly after printing to avoid it sticking.

Printing

A piece of foam rubber about 2.5 cm (1 in.) thick should be used in place of etching blankets to force the damp paper down into the recesses of the inked block. Begin by taking the pressure off completely (winding the pressure gauges in an anti-clockwise direction) and increase it gradually; so long as you do not disturb the print, you can continue running it back and forth through the press, adjusting the pressure as you go. Correct pressure can be judged from the back of the printing paper; when it looks suitably embossed, have a peep at the print by peeling it back a little way from the inked block.

1. Place the inked collagraph block down in the centre of the bed of the press, on top of a sheet of newsprint. This will keep the bed clean and will also give you a guide for placing the paper.

2. Place the dampened paper down centrally onto the block.

3. Carefully lay the foam rubber over the paper, taking care not to disturb it; wind through the press.

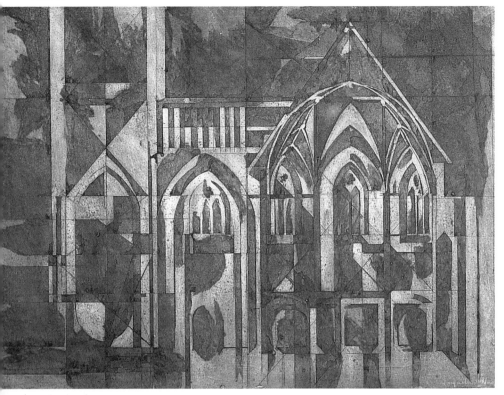

'Disused Ruin', by Jacquie Newell, 76 cm x 51 cm (30 in. x 20 in.).
This large collagraph was made as for a relief card print (see captions for
Alison Newson's print on p. 40). However, after sealing with shellac, it was
inked-up as for an intaglio print by squeegeeing ink onto the block with a
small piece of card and then wiping back with scrim. The ink is then held
in the lower levels of the image.

Needless to say, you must re-ink for each print, although a second printing
without re-inking will certainly give a result of reduced strength.

Drying and flattening the prints
See p. 67 at end of Chapter Four.

Cleaning up
The block can be cleaned because it has been so thoroughly sealed. See
p. 16 in Chapter Two. If using toothbrushes, clean these also to retain
softness.

Above: *'Euroclydon', by Pamela Challis (Australia), 57 cm x 87 cm (22½ in. x 34¼ in.).*
Working on a base of coated hardboard this printmaker from Canberra, created her collagraph using thick, white acrylic housepaint (which has a buttery consistency) and palette knives. The mountains were built up using PVA glue and impasto medium. The collagraph was coated with shellac several times and left to cure for two weeks before sanding, scraping and proofing. The block was then shellacked again. It was printed using Charbonnel etching inks (black and Prussian blue) on dampened Arches BFK creme paper.

Right: *Untitled by Jacqui Galise, 20 cm x 28.4 cm (8 in. x 11 in.).*
Acrylic 'texture paste' was applied with a palette knife to a cardboard base. Black ink was rubbed into the areas below the surface (intaglio inking); red, green and yellow were then applied to the top surface (relief inking) using small rollers.

Chapter 6
SCREENPRINTING

This is another of the printmaking processes that can be carried out in a low-tech fashion at home. Screenprinting is a stencil method, where ink is dragged across a mesh, allowing it to print onto the paper in selected areas only. Commercially, it is used for textiles, signage and ceramics.

Traditionally, screenprinting inks were oil-based, which meant using some very pungent and toxic chemicals for cleaning, but there has been a huge trend recently towards the use of water-based and acrylic-based inks.

'Bush Fire Dreaming', screenprint by Gabriella Possum (Australia),
reproduced by courtesy of the Rebecca Hossack Gallery, London,
52.8 cm x 79.1 cm (20¾ in. x 31¼ in.)
Print by indigenous Australian artist using traditional designs handed down through generations of ancestors; her colours are inspired by the Central Desert landscape of Australia.

Basic equipment needed

The screen

The first item you will need to consider is the screen. Check out the cost of buying a pre-made, professionally stretched screen from a printmaking supplier, or a self-assembly kit. If your budget is really tight, however, you can make one yourself from scratch.

Unless you have severe space problems, consider a reasonable size such as 60 cm x 45 cm (2 ft x 1 ft 6 in.), which will enable you to print images of nearly that size, or a good deal smaller. The best frames are made of aluminium, but pre-stretched frames made of wood or MDF are also available and are cheaper.

Wood glue and corrugated pins (buttress nails) make a very sturdy frame.

To make a screen you will need:

- a length of 5 cm x 5 cm (2 in. x 2 in.) timber, which should be straight and as knot-free as possible;

- a metre of polyester mesh (or nylon or cotton organdie);

- resin wood glue;

- eight corrugated pins (called buttress nails);

- a hammer and saw;

- parcel tape/gum-strip – at least 5 cm (2 in.) wide.

1. Cut your wood accurately to length as shown, then lay your pieces of wood in position on a flat surface.

2. Follow the instructions on the wood glue bottle; i.e., a thin coating on each surface to be joined; leave for the required amount of time before sticking together; this will make your frame very secure.

3. Hammer in two corrugated pins (as shown) in the top of each joint whilst the glue is still wet (wood glue is brittle when dry and would probably crack when hammered).

4. Running sandpaper around the outer edges and corners of the frame will avoid snagging the fine mesh.

5. To avoid warpage from the constant wetting, varnish the frame to make it waterproof.

6. To ensure a really thin film of ink passes through the mesh (and therefore cut down on paper warpage through excess water), try and get a really fine fabric. Polyester 120T or 140T is the best. Alternatively, cotton organdie is perfectly adequate, in addition to being inexpensive and easily obtainable – try to get one which has 90 threads to the inch (2.5 cm).

7. Place the frame onto the fabric and allow a 5 cm (2 in.) excess all the way round. Mark this measurement with a ruler and pencil straight onto the material and then cut out with scissors.

8. Stretch as shown in diagram, stapling fabric onto the sides of the frame – securing corners last of all.

9. To complete, seal edges with 5 cm (2 in.) parcel tape or gum-strip, to prevent it from seeping underneath when printing. Cut four strips to the length of the internal screen measurements; dampen and place inside the screen from corner to corner, half on the wood and half on the mesh. Gum-strip can be coated with shellac when dry.

Hinging the screen for printing

You will find it immensely useful to go to the further trouble of hinging your screen to a sturdy, flat board which is larger than the screen itself.

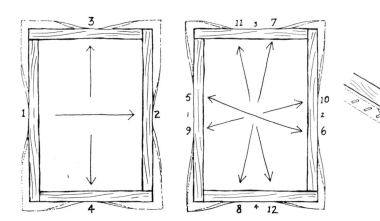

Starting at the centre of each side of the frame, stretch the mesh tightly and staple into position. Work from the centre, as indicated, tackling the corners last of all.

RUBBER BLADE

The attachment of a 'kick-leg' to one side of the screen makes printing easier. A piece of wood is loosely nailed to the side of the screen, which swings down when the hinged screen is raised, propping it up at an angle.

Squeegees can be bought from print-making suppliers or substituted by window-cleaning squeegees.

This will act as a printing table and allow you to lift the screen easily after each print. The hinges needed are of the type that are in two separate sections, held together by a hinge pin. The screen will be easily removed from the printing base enabling you to work on the stencils, clean etc. Attach the hinges to one of the shorter sides of the screen, after the mesh has been applied; these can be unscrewed entirely, should you need to change the mesh.

The squeegee

A squeegee is used for pulling the ink firmly across the mesh to transfer it onto the paper. A long window-cleaning squeegee works well and is much cheaper than the real thing. Printmaking suppliers price squeegees by the centimetre, inch or foot. Whichever type you buy will need to measure at least 5 cm (2 in.) less than the shortest internal measurements of your wooden screen frame. The squeegee should be wider than the stencil shapes to be printed.

Images and stencils

Considering an image

Any type of drawn or painted idea can be converted into a screenprint and results can vary from flat areas of colour to sketchy linear printed marks. One of the first things to decide upon is how many separate colour printings your intended image is going to need. It is possible to get a lot of mileage out of three printed colours, particularly if you use transparent inks, which will create bonus colours when overprinted – e.g., transparent warm red printed over yellow will produce orange.

'Taste Sensation', by Dale Devereux Barker, 76.2 cm x 55.9 cm (30 in. x 22 in.).
Combining two screen-filler stencils and a drawing fluid/screen-filler stencil,
this screenprint uses the reduction method (see p. 82).

Stencil making

Paper stencil method

The easiest and quickest sort of stencil is a piece of paper with a shape cut
or torn from its centre; the missing areas will result in a flat shape of
printed colour.

Most papers will be penetrated quite rapidly by the water content of the
ink and break down. However, grease-proof paper and waxed craft paper
make excellent stencils for water-based inks, as they resist the water
content for much longer. Sugar paper is also good as a stencil material.

The paper from which the stencil is cut should be the same size as the
internal area of the screen.

Screen-filler stencil method

For this stencil-making method, you will need some water-based screen-
filler from a printmaking supplier.

1. Place the screen over your intended image (drawing or photograph)
 and trace it directly onto the mesh with a soft pencil.

2. Stir the screen-filler thoroughly.

3. Prop up the screen to avoid contact with table and paint out the non-image areas with the filler and a paintbrush. Large expanses of mesh can be rapidly filled by using small rectangles of mounting board to squeegee the filler across the mesh. If a hard edge is desired, stick down draughting tape on the mesh first, and paint or squeegee the filler to the tape edge. By working your filler brush a little on a piece of paper first, you can achieve a dry, soft effect that will give a more tonal edge to the stencil.

4. When dry, turn the screen over and do the same on the other side of the mesh; leave the screen to dry.

5. If dribbles of screen-filler form, smooth them out with your brush. If screen-filler should dribble into your image area, wipe it back with a damp sponge or brush until all traces of it are gone from the mesh; blot out dampness with tissue. Repaint the stencil edge if necessary.

When the filler is dry, hold the screen up to the light and check for pin holes; these will print unless spotted-out with more screen-filler.

'Salmon Ghosts V', by David Wynn Millward, 27.9 cm x 45.8 cm (11 in. x 18 in.). This print is made entirely with screen-filler stencils, painted directly onto the mesh; it involves three printings. The transparent ink is blended from one colour to another, across the width of the screen. Over-printing creates additional colours.

Candle-wax filler

Melted candle wax is a good alternative filler for stencil-making; keep the wax from solidifying by using a food-warming hotplate. After printing, remove wax from the mesh by ironing it out between several sheets of newspaper.

Reduction method using screen-filler

Assuming that you are printing your lightest colour first, it is possible to block out a little more mesh after each printing to achieve the stencil for the next colour. The reduction method is common when making linocuts.

Drawing fluid and tusche stencil methods

Drawing fluid is a solution specifically designed for the purpose of stencil-making, and should be used in conjunction with screen-filler. It can be bought from a printmaking supplier. This method allows you to work in a positive fashion, painting your intended image directly onto the mesh.

'Ely, East End', screenprint by Margaret Steiner,
47 cm x 39.4 cm (18½ in. x 15½ in.).
Margaret Steiner makes excellent prints on her extremely basic set-up at home. She has a home-made screen stretched with nylon organdie and prints with a long, window cleaning squeegee. Her ink is made with a base of wallpaper paste mixed with powder colour and her stencils are created by painting melted wax onto the mesh.

1. Trace your image onto the mesh with a soft pencil.

2. Prop up one end of the screen and paint the intended image with drawing fluid (shaken well first) or liquid lithographic tusche – either with a hard edge or a drier brush mark. Turn the screen over (mesh up) and leave to dry or use a hairdryer on a warm (not hot) setting; don't get too close to mesh.

3. Stir screen-filler well; if cold, it can be warmed up by placing in a bowl of warm water. Spoon some into the elevated frame (right-side up) and squeegee over the entire screen with a piece of stiff card (change card, when soggy), or plastic glue spreader. Leave to dry thoroughly.

'Shop Local', by Janet Brooke, 55.9 cm x 76.2 cm (22 in. x 30 in.).
Inspired by the environment of East London where she lives, Janet Brooke's
screenprints are printed from a combination of stencils made from her own
photographs and other, hand-drawn and hand-cut stencils. This print involves in
excess of 30 printings.

4. Now wash out drawing fluid by running the screen under a forceful *cold*
 tap. This will wash away the areas to be printed leaving bare mesh.

Photostencils

The photostencil

Photostencils are simple to make and many printmakers use no other
method. The screen mesh is coated with photo-sensitive emulsion and a
drawn or photographic image is exposed onto it. The image first needs to
be made onto a transparent or semi-transparent material so that light can
penetrate through to the coated screen, hardening the emulsion in the
non-image areas.

Making the image on a 'positive'

For exposure purposes, all 'artwork' should be made in black, but this
has nothing to do with the final printed colour. A sheet of acetate can
be drawn upon with a chinagraph pencil, drawing ink, acrylic paint, oil
pastel, or anything waxy that will make an opaque mark. Acetate can be
de-greased first, see p. 52 in Chapter Four. Alternatively, an image made
on layout paper or photocopy paper can be made semi-transparent by

rubbing with a little cooking oil. Tracing paper is ideal for drawing directly onto, and can also be fed through a photocopier to transfer a photographic or drawn image. A special sort of acetate is obtainable for photocopying – be sure that the setting is sufficient to give a strong black image.

Making the exposure

1. De-grease your screen mesh thoroughly on both sides by the recommended product or a bathroom cream cleaner, sponge and hot water.

2. Mix your emulsion to the maker's instructions, away from bright light.

3. Place the screen upright in a tray (to catch drips) with the underside facing you. The emulsion will need to be squeegeed across the mesh using a 'coating trough', or a plastic ruler. Tilt the trough/ruler and wipe the emulsion upward, over the screen mesh in bands, until the mesh is thinly coated. Turn screen around immediately and coat other side. This part of the operation can be carried out in low light and does not need a darkroom.

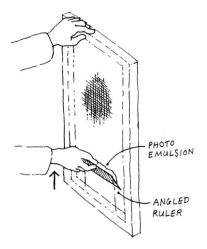

PHOTO EMULSION

ANGLED RULER

It is not essential to have a coating trough, a plastic ruler will make an excellent substitute to squeegee the emulsion across the de-greased mesh. Pour the photo emulsion into the trough or against the mesh and angled ruler.

4. Dry the emulsion coating with a dryer in dull light or put screen into a drawer to dry (away from light).

Making the exposure

There are various ways of exposing your image onto the emulsion coating:

Using a light box

Place your positive transparent image onto the glass of the light box, the correct way up; place the dry screen directly on top and cover with a blackout cloth, a piece of hardboard painted black or anything that is dark and matt. Exposure time will have to be determined by trial and error, as it will depend on strength and distance of the bulb to the screen. The bulb can be ultra-violet or an ordinary bulb with a strong wattage, such as 150W or 250W (available from an electrical shop).

'Black City II', screenprint/watercolour by Richard K. Mills (USA),
71 cm x 86.4 cm (28 in. x 34 in.)
All ten stencils making up this print were hand drawn onto 'Mylar' (the trade
name for a thin smooth or textured plastic sheet which can be used as a trans-
parent base in photo processes) using litho chalk, etc. Each separation was exposed
as required, onto the prepared screen and then washed out in the usual manner.
There is also some watercolour applied to the final print.

Exposing without a light box

Place screen the correct way (as for printing) on a table with the image
transparency in the centre of the mesh (the correct way up). Place a clean
piece of glass or Perspex over the transparency to make close contact
between emulsion and image. The light source should shine down directly
onto the image.

Expose for 10 minutes if using a 250W bulb and 45 minutes if using
150W bulb.

Washing out the stencil

Wash the exposed screen with cold water using as much pressure as you
can muster. A hair-washing hose attachment will suffice but greater
pressure is even better. The area of emulsion blocked out from the light
by your black image will be still soft and will wash away, showing through
to clear screen mesh.

'Grantchester', by Mary Louise Coulouris, 55.9 cm x 76.2 cm (22 in. x 30 in.).
This six-colour print was inspired by the garden of the Orchard Tea Room in
Grantchester, which has in the past received such distinguished visitors as
Wittgenstein, Bertrand Russell, Virginia Woolf and Rupert Brooke. The photo-
stencils were made from enlarged photocopies on tracing paper and combined
with hand-painted areas worked directly onto the screen with filler.

Inks and paper

Screenprinting inks

Water-based inks remain water-soluble when dry, whereas acrylic inks will
be waterproof. All of the ink manufacturers produce their own helpful
leaflets giving advice on getting the best from their particular product.
These will explain the benefits of adding retarders, extenders, pastes, etc.,
to their brand of ink.

Inks should be thoroughly stirred to a creamy consistency in plastic
cups or cans; cover with plastic food wrap to store. Use plastic spoons or
sticks; these can be washed and used again for mixing. Water can be added
to some inks if too thick, but it is best to take the advice of the manu-
facturers, as each brand of ink is slightly different. Look for an extender
base in the range of inks you buy to make your ink colour transparent, in
addition to making inks go further. Transparent inks overprint beautifully
to make additional colours.

Wallpaper paste ink

Wallpaper paste makes an excellent and extremely inexpensive ink base.

Simply mix up a small quantity of wallpaper paste to the recommended paste/water proportions and add powder paint or fabric dyes. Although powder colours are quite basic and bright, they can be toned down by adding the opposite colour on the spectrum (see diagram on p. 35). Knowledge of mixing and neutralising will save a fortune on inks, as you can then create any subtlety desired.

Printing paper

The water content in all of the inks can cause printing paper to buckle. A fine screen mesh and a medium or heavy-weight paper will cut down or eradicate this warpage. 200 gsm to 300 gsm smooth paper or even heavier weights, such as thin card, are ideal. Make notes of the papers you prefer for future reference. Cartridge paper will buckle, but then settles down somewhat, given time. Always pull the first few proofs on cartridge to check the quality of your print and continue printing with your more costly paper. These first prints will be handy for proofing subsequent colours.

Printing

Hinge the screen into position and place the printing paper underneath centrally; stick down paper 'stops' on two adjacent sides as described in the following section. Spoon the ink into the frame along the farthest edge, then pressing down hard with the squeegee, sweep the ink towards you, covering the whole width of the mesh. Lift the screen slightly (away from the paper underneath) and flood the ink back to the printing position using the squeegee. When printing forwards or flooding back, the squeegee should be held at a 45° angle towards the direction it is travelling to ensure a thin layer of ink.

Flooding prevents the screen mesh from drying out and clogging, in addition to getting your ink into the right position for your next print. You can now lift the screen higher until the kick-leg drops to support it, and remove the print to dry.

If prints are not flat when dry, a drawing board can be placed on top to flatten them.

Registration of colours

For two (or more) colour prints you will need to adopt a method of registering all of the printings accurately together. For successful registration, printing papers need to have two adjacent sides cut to a right-angle.

1. Place the prepared screen into hinged position (flat).

2. Next, place a piece of printing paper underneath the screen, in a central position.

3. Lift the screen up. Place three 6 cm (2.3 in.) strips of masking tape and stick them onto the board, directly around the paper edges – two pieces to the long edge and one to the short edge (as in diagram p. 79). These are called 'stops' and are used for lining up each sheet of paper, prior to taking the prints.

4. After printing all first colour, clean screen and remove paper stops.

5. Prepare screen for second-colour printing and place back in hinged position (flat).

6. Line up one of your prints with the new stencil by looking directly through the mesh.

7. Place paper stops in new position around paper. Print second colour onto first.

Cleaning up

Cleaning up

You need use nothing stronger than tap water and a sponge to clean water-soluble inks.

After printing, spoon or scrape excess ink from the screen into your original mixing pot (this can sometimes be used as the basis of another colour), or onto newspaper if you intend to bin it. If you wish to carry on printing the same stencil in another colour, place plenty of newspaper under the screen (still in hinged position) and wash away ink with a sponge and a bowl of water. Blot water from the screen with a sponge, and then cotton rags, before adding another ink colour to the screen frame.

If you have used acrylic ink you will need to be speedy in removing it once the last print has been taken. Use warm water and a soft brush and scrub gently away. If acrylic inks are allowed to dry, you should spray the mesh with a window-cleaning spray.

When printing is finished, detach the printing frame from the hinges and wash both sides of the screen frame and the mesh with warm water and a sponge, in the sink or bath.

Opposite: 'Mexican Market', by Laura Reiter, 57 cm x 87 cm (22½ in. x 34¼ in.). Laura Reiter's prints involve up to 30 separate printings. Her stencils are made by using direct methods, such as drawing fluid and screen-filler.

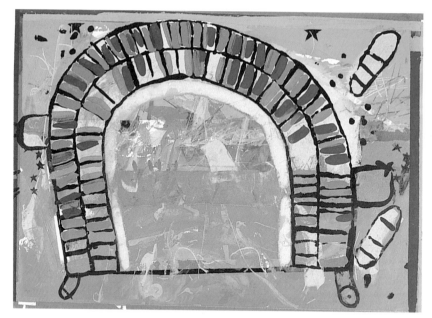

'Pin Ball Machine', by Trevor Allen Abbott, 49.5 cm x 66 cm (19½ in. x 26 in.).
This print is actually a monotype using the screen process and involves several
registered colour printings. The brightly coloured inks were painted directly onto
the screen mesh and a transparent ink printed across, transferring the image onto
the paper.

Removing screen-filler

Wash the screen with hot water and then both sides of the mesh should be
gently rubbed with cream bathroom cleaner and a sponge. Leave on for
several minutes before rinsing off, using a forceful tap or shower head,
continuing to rub if necessary.

Removing photostencils

Some photostencils can be removed with hot water and ammonia-based
kitchen cleaner, although this is not advisable if suffering from respiratory
problems. A stencil-remover can be obtained for spraying onto the mesh;
check with the manufacturer's leaflet.

For more information on screenprinting, please see *Water-based
Screenprinting* by Steve Hoskins in this series of handbooks.

Chapter 7

LITHOGRAPHY

■ Discovered by Alois Senefelder in 1796, this ingenious method of making a print is based on the fact that grease and water do not mix. Zinc or aluminium lithographic plates, limestone slabs or specially coated paper 'plates' will all absorb grease. An image is made by drawing directly onto them with grease-based materials. Printing is carried out by keeping the non-image area damp, then an ink-charged roller can be safely passed over the plate, inking-up the greasy image only.

Today, lithography is the most common method of commercial printing, but probably the least-used method in printmaking, having disappeared from many art colleges in recent years.

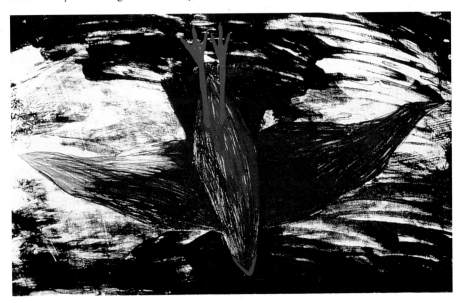

From 'The Girl in the Treehouse', by Anne Gilman (USA), 45.7 cm x 76.2 cm (18 in. x 30 in.).
Three-colour stone lithograph from a limited-edition artist's book entitled *The Girl in the Treehouse*. The deep blue was printed first, from a tusche and alcohol wash. The beak and talons of the bird were painted out with gum arabic to prevent them from accepting the tusche. Secondly, blue-green was printed (with the beak and talons again gummed out). The final printing was the red, defining the bird and filling in the beak and talons.

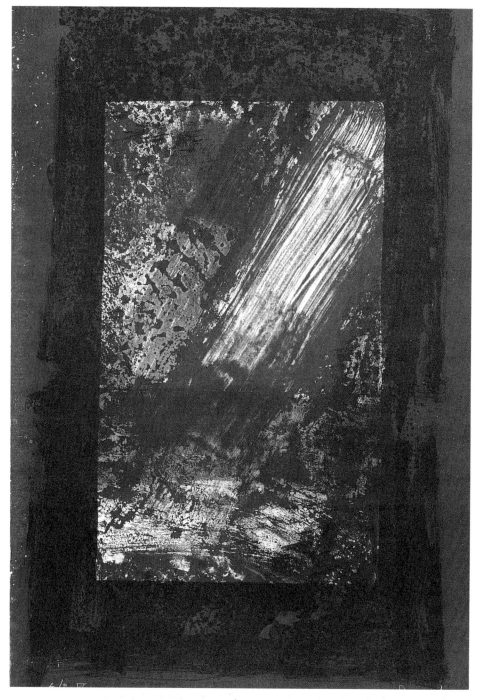

'Waterlees', by Stanley Jones, 44.5 cm x 30.5 cm (17½ in. x 12 in.).
Two-colour stone lithograph using tusche washes.

Drawing materials for lithography

There are drawing materials produced especially for lithographic work, but anything that contains fat or grease can be used to make an image on the plate or stone. Litho chalks, tusche (litho drawing ink in solid or liquid form) and a black slab called a 'rubbing block' all contain the right amount of grease to ensure that what you see drawn onto the plate is exactly what will print. However, you can also use chinagraph pencil, oil pastel, wax crayon, candles and carbon paper.

Lithographic 'tusche'

Liquid tusche can be applied with a brush, a dip-in pen, or flicked onto the plate with a toothbrush for a stippled effect. It can be diluted down with distilled water (or purified water which can be obtained free from the ice that forms on your freezer walls) or alcohol, to make tonal washes.

Tusche can be bought in solid form and then melted into a warmed metal jar-top and mixed with water, methylated spirits or alcohol to make a liquid drawing ink.

Test print made from a paper litho 'sketch' plate using (left to right): 1. litho chalk (in pencil form) 2. oil pastel 3. chinagraph pencil 4. a candle 5. side of litho chalk (in stick form).

Litho chalks

Litho chalks make grainy marks, similar to chalk pastel on paper. They are graded from no. 1 for the softest in the range, through to no. 7 for the hardest. Good printmaking suppliers will also have a range of crayon thicknesses, from a narrow girth, to a fat 5 cm (2 in.) width stick. Flat tablet crayons are also available for making chunky marks.

Rubbing crayons

The lithographic rubbing crayon is extremely soft and smudgy and more like soft oil pastel than regular litho chalk. These can be used to draw directly onto the plate and then smudged with the finger, soft cloth or chamois leather.

Carbon paper

Drawing through the back of carbon paper placed directly over a litho plate will deposit a fine line of grease. This will print just as it appears on the plate.

Deciding on an image

To fully exploit lithography, think of it as the one printmaking medium that can look exactly like drawing and plan from there. Exploit the huge variety of qualities that the chalks, crayons, ink washes, oil pastels, etc., can offer.

Drawing in black; thinking in colour

All materials designed to draw on litho plates or stones contain a brownish-black pigment to enable you to see the image at the time of making the plate. However, the pigment of the drawing will eventually be washed out leaving the image as transparent grease and this can be inked-up in any colour of ink. In the case of paper plates, the pigment of the drawing is not washed out prior to inking-up.

As with most printmaking processes, each colour to be printed will need to be isolated and drawn onto separate plates. These will be printed one by one, registering the colours together.

'Boards & Bags', by James M. Martin (USA), 53.2 cm x 78.7 cm (21 in. x 31 in.).
One-colour print made with tusche washes on an aluminium litho plate.

Paper plate lithography

The qualities of lithography can be discovered and enjoyed using paper 'plates'. These plates have the same sensitivity to grease, but do not require chemical processing prior to printing. An American brand called 'litho-sketch paper plates' can be bought from some suppliers, along with the special processing 'litho-sketch solution'. This system of lithography is quite basic, but it is cheap, and will certainly give a good idea of the qualities possible when working on zinc, aluminium or stone. One of the great advantages of these paper plates is that they can be printed on an etching press.

Handle the paper plates with 'paper fingers' (small folded pieces of scrap paper), as the grease from your hands will otherwise be absorbed into the plate and will ink-up.

'Furnaceman', by Jane Stobart, *20.3 cm x 15.3 cm (8 in. x 6 in.).* Paper litho-sketch plates are ideal for slipping into the back of a sketch-book and used on location drawing trips. This print was drawn with litho crayon, candle and oil pastel and printed on an etching press using dry Fabriano paper.

1. Make a drawn guide in advance if you wish, tracing it down onto the plate using carbonless transfer paper, or by applying coloured chalk to the tracing. This will give you confidence to work freely and directly. If you print on an etching press or a 'direct' litho press, you will need to trace down in reverse, then the action of printing will set the image the correct way around.

2. Using a grease-based drawing material, make your image onto the paper plate.

3. When the drawing is complete and you are ready to print, carefully *dab* over the entire plate with the 'litho-sketch fluid', using a sponge or cotton wool, to avoid smudging the image.

4. Keeping the plate damp in this way, ink it up using a relief printing roller. Litho printing ink or etching ink (both oil-based) can be used, thinned with some medium copperplate oil. The ink should be quite oily and sticky, rather than stiff.

5. A print can be taken on a lithography press or an etching press. If using an etching press, it is an idea to place the inked paper plate onto a bevelled etching plate first (preferably the same size), to avoid altering the pressure of the press drastically (although I do reduce the pressure by about half a turn of the pressure screws). This will, of course, give your print an indented plate mark. I made good, true prints using dry Fabriano paper, 270 gsm.

Metal and stone lithography

Lithographic prints made from grained zinc, aluminium plates or prepared stones, involve a rather complicated chemical processing operation, which ensures long, trouble-free print runs. For details of this, I refer you to *Stone Lithography* by Paul Croft in this A & C Black series. However, for the beginner wishing to make not more than 10 to 15 prints, simpler processing is possible.

Gumming-up the edges
Grease from any source (intentional or unintentional) will be absorbed by the plate or stone and become part of the print. Unwanted finger prints can be avoided by a simple treatment to de-sensitise the edges. Liquid gum arabic will fill up the absorbent plate surface, making it safe to handle. Make a 2 cm (¾ in.) border of *very* thin gum arabic, on all edges of the plate. Dip a sponge (kept for this purpose) in the gum, and then wring out tightly, before wiping on. Dry the plate immediately with a hair dryer.

Making the image
If working from a drawn guide, trace it down onto the plate using carbon-less transfer paper or by chalking the tracing. Charcoal can be used to draw directly onto the litho plate for a grease-free drawing guide. Remember to reverse your image, unless using an 'offset' litho press.

Simple processing with 'gum-etch'
Once you have drawn your image onto the litho plate or stone with grease-based materials, the non-image area will need to be de-sensitised to grease. To do this, you will need a solution of gum arabic, containing a proportion of nitric acid, known as 'gum-etch'. This will have a more permanent de-sensitising effect than gum arabic alone.

You can buy gum-etch or make your own. The proportions needed are: six or seven drops (from a pipette) of full-strength nitric, to one fluid ounce of gum arabic. Always add acid to gum and never the other way around. Carry out this operation in a well-ventilated area or in a fume-extraction booth. Wear a mask, gloves and a sturdy overall and shoes when handling acids and keep a supply of water at hand in case of splashes.

You will need:

- powdered resin
- powdered French chalk or talcum powder
- some cotton wool
- gum-etch (see recipe)
- a sponge and some clean water.

1. If you have used litho drawing ink or tusche to make your image, leave plate to dry thoroughly then dust the entire image with powdered resin, applied with a piece of cotton wool. It is advisable to wear a mask when using any airborne materials.

2. Do the same with French chalk or talcum powder using another piece of cotton wool. Dust off excess.

3. Wearing thin gloves, pour a small pool of gum-etch onto a non-image area of the plate, then taking a sponge, carefully dab it all over the image (do not wipe at this stage, for fear of smudging the drawing).

Christmas card, 1998, by Bernard Cheese, 20.4 cm x 9.5 cm (8 in. x 3¾ in.)
Three separate printings can be clearly identified here. The drawing has been carried out with litho chalk and litho drawing ink (as depicted!) on zinc plates.

4. Next, cover the whole plate with the gum-etch by wiping firmly with the sponge from edge to edge of the plate or stone (is is now safe to wipe over the image).

5. The gum layer should be as thin as you can get it, or it will flake off whilst drying, leaving the plate exposed. Wring out your sponge until you can get no more gum-etch from it, and wipe the plate or stone from edge to edge again, thinning the gum layer down still further.

6. To dry the plate or stone completely, remove gloves and pat the entire surface with the flat of the hand. Continue until the surface is absolutely dry. Wash hands.

7. Leave plate 'gummed up' overnight or longer if possible.

Printing

Lithographic presses are either 'direct' or 'offset'. On a direct press, a sheet of metal called a tympan is placed over the inked stone/plate and paper, then the whole bed is rolled underneath a pressure bar, making a print in reverse. On an offset press, the inked image is transferred from stone or plate onto a large diameter roller first, then onto the paper; here, the printed image is not reversed.

1. Wipe the bed of the press with some pure, liquid gum arabic, then stick the plate onto it, making it secure for inking-up.

2. When the gum-etch has remained on the plate overnight, wash out the colour of the image (through the gum) with white spirit and a small, clean piece of rag; the image will now appear as grease alone.

3. Taking a damp sponge, wipe over the entire plate; the water will now spring away from the greasy image and lie only on the non-image areas.

4. Keeping the whole plate or stone damp (but not wet), roll up the image firmly and slowly in your preferred ink colour. A lithography roller usually has a suede surface and a 10 cm (4 in.) diameter. Continue the damping and inking procedure, until you have built up the required intensity of ink. Never allow the non-image areas to dry during inking.

5. When image appears sufficiently inked, dry off the damp plate areas with a hair dryer.

6. Place printing paper in exact registration with the litho plate (as described in registration method on p.100). If using a direct press, close the tympan and roll under the press.

7. The printed image may be weak for the first print or two, but the strength should build up with repeated dampening, inking and printing.

Registration for colour printing

Registration method using an etching press

For the two-colourprint *John and Henry*, which was printed on an etching press, I devised a simple registration technique. Firstly, I found a bevelled etching plate and cut the paper plates to the same size. It is not absolutely necessary to use a metal plate underneath, but it avoids having to drastically increase the pressure of the press (I reduced pressure by only half a turn of the pressure screws). Handle paper plates with paper fingers to avoid grease from hands.

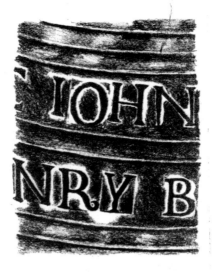

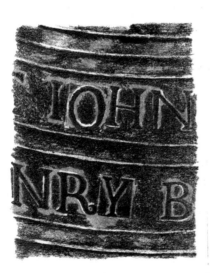

'John and Henry' by Jane Stobart, *23 cm x 17 cm (9in. x 6.5 in.)*. Two-colour print made from paper plates, using a simple registration technique (see diagram p. 100) and printed on an etching press.

1. Trace image down onto each paper plate in an identical position.

2. Draw your two colour separations with a grease or wax-based drawing material. A pale colour such as yellow, should be drawn quite heavily to compensate for lightness of hue.

3. Place etching plate (if using) in the centre of the etching-press bed and mark its position with strips of masking tape, as shown on p. 100.

4. Now cut your printing papers allowing for a margin all around the plate size, e.g., 3 in. (7.5 cm) for all margins. Place strips of masking tape down around the exact position of the paper, as shown. Now the printing paper can be placed and then replaced, in the same position for each printing.

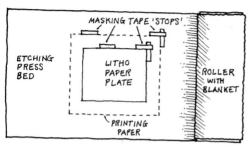

Simple method of registration when printing paper plates on an etching press.

Registration using a direct press

Bernard Cheese uses the simplest method of registration on his direct litho press. He trims his paper to the exact size of his litho plates and registers one corner and one adjacent side of the paper with corner and side of the litho plate.

Storing the plate or stone

If you wish to make more prints at a later date, you will need to wash out any coloured ink (see 'Printing' section: no. 2 on p. 98) and roll up the image in non-drying black ink. Gum-up the plate in gum-etch, then pat dry and store in a dry place.

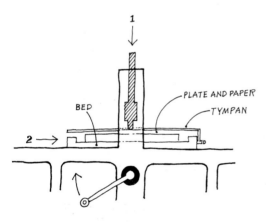

A direct litho press.
1. Pressure is brought down.
2. The bed is then wound through the press to make a print.

Chapter 8

EDITIONING AND FRAMING YOUR PRINTS

Proofing and editioning

'Proofs' are prints taken periodically, during the development of your block or plate. They will offer you a chance to experiment with different papers and colours of ink. Keep a note of papers used and your colour experiments, by thinly dabbing a swatch of each colour in the print margin, and noting down how you mixed it. Proofs can also be used to work out your next moves, by drawing or painting on top.

Initially, more will be learned by experimenting with different papers and ink colours, than attempting to produce large, identical editions, and it is far more likely to keep printmaking alive for you. Having drawers full of prints that you no longer exhibit and therefore have little likelihood of selling is expensive. Be realistic about an edition size until you are sure of how popular your work is going to be.

If you do decide to edition a print, bear in mind that some intaglio methods, such as dry points on zinc, wear down quickly, making large editions unlikely. I take 6 to 10 prints from an edition of 30 etchings, and then print more, as it becomes necessary.

²⁄₂₅ Blacksmiths JStobart

In an edition size of 30 identical prints, the first will be numbered 1/30, the next, 2/30, and so on. Artist's proofs, often abbreviated to 'A/P', can make up 10% of the edition. You are 'permitted' (acceptable to print buyers and galleries) three Artist's Proofs on top of an edition of 30 prints.

Non-editionable prints

A 'unique print' is a term for a one-off image, unlike any other produced. Despite the fact that this may be printed from a matrix (block, plate etc), it is made unique by different paper and/or colour of ink to that used in the editioned prints.

Monotypes are one-offs where no matrix exists (see Chapter Two). Prints in an edition will need to be as similar as possible – if a buyer wishes to purchase an unframed version of something seen framed in an exhibition, they will expect it to be identical, despite being a different edition number.

Keeping a book of sales will prevent the possibility of mistakenly giving two prints the same edition number. It will also be an excellent source of names and addresses for future exhibition mailing lists.

Framing your prints

Finally, it is extremely important to frame securely and discreetly. At some of the open print exhibitions, many good pieces of work are rejected purely due to garish coloured mounting boards, over-fancy mouldings or badly made frames which are falling apart. It is worth remembering that your print will be seen alongside many other works. If the print is strong, the frame need only be reasonably plain and neutral.

Good-quality printmaking papers deserve acid-free mounting board, the cheapest of which is called p/h neutral. This term means that the damaging acid content in the paper or board has been neutralised and will no longer be a serious threat to the print over time. Back the print with acid-free tissue and p/h neutral cartridge paper (most is these days). Even the tape that secures your print to the mount should ideally be acid-free. The purest and safest mounting boards are termed as 'archival' or 'museum quality' and are frightfully expensive.

The hanging position of prints is also important in conservation terms; avoid hanging in direct sunlight or above a heat source, to preserve paper and colours. It would be nice to think that your print will remain in good condition and still be enjoyed in years to come.

GLOSSARY

Aquatint
Etching process used to create tonal effects; traditionally achieved by means of a fused sprinkling of powdered resin.

Baren
Traditionally, a Japanese hand burnishing tool covered in bamboo sheath, used to make relief prints.

Bevel
Filed, angled intaglio plate edge, made to prevent cutting blankets on press.

Biting
Term used for the corrosive action of a mordant (e.g. acid) on metal.

Burin
Type of engraving tool used on wood or metal.

Burnisher
Small steel tool, used for rubbing down intaglio image, to lighten or remove bitten areas.

Burnishing
See above; also method of taking a relief print without use of press.

Burr
Ridges of metal created on either side of a drypoint line, giving characteristic quality and richness.

Chinagraph
Grease-based pencil, which can be used in etching and lithography.

Collagraph
Intaglio print taken from block created by sticking collage elements onto a base.

Dabber
Leather-covered pad, used for laying etching grounds.

Drypoint
Intaglio technique made by scratching an image directly onto a metal plate.

Embossing
Firm impression made onto paper from relief block. When involving no ink it is called 'blind' embossing.

Engraving
Image cut into metal (intaglio) or wood (relief), using gravers, burins, etc.

Etching
Intaglio process involving a mordant (acid, etc) to 'bite' an image into a metal plate.

Ferric Chloride
Also known as perchloride of iron; a corrosive salt in liquid form, used in etching process as a substitute for acid.

Gesso
Plaster of Paris mixed with glue, which can be used for creating relief blocks.

Gouge
Relief cutting tool.

Graver
Engraving tool.

Ground
Beeswax or acrylic-based material applied to etching plate, to form acid-resist coating, which is drawn though prior to biting; can be hard or soft.

Gum Arabic
Liquid solution used to de-sensitise litho plates.

Hotplate
Metal box or metal table which is heated for laying etching grounds or printing intaglio plates.

Intaglio
Printing process in which the image to be printed is made below the level of a metal plate, by means of scratching, engraving or etching.

Lift ground
Method of creating positive, freely painted image/marks onto etching plate for biting.

Matrix
Term used for the plate, block, stone, etc. from which the prints are made.

Multi-Density Fibreboard (MDF)
Heavy, dense board used in the building and furniture industry; can also be used in relief printmaking.

Monotype
One-off, unique print.

Multiple tool
Engaving tool, which cuts several parallel lines at once.

Nap roller
Suede surfaced wooden roller used in lithography.

Needle
Etching tool used to draw through grounds and expose metal for biting.

Perspex™
Translucent plastic sheet which can be used for making drypoints, monotypes and engravings.

Planography
Method of printing from a flat surface, as in lithography.

Proof
Print taken (in any printmaking discipline) en route to final state.

Reducing medium
Transparent ink base, used to dilute the strength of ink colour.

Registration
Method adopted to ensure that separate printed colours line-up into the intended position on the final print.

Relief
Printmaking method whereby the uppermost surface of the material is inked-up and printed from.

Resist
Material which forms a barrier against acid etc.

Roulette
Intaglio tool with a toothed wheel for making perforations through a ground or directly onto a plate.

Scrim
Ink wiping canvas used in intaglio printing; also known as 'tarlatan' or 'wiping canvas'.

State
Print taken during the development of a plate etc; also called 'proof'.

Stopping-out varnish
Acid-resist varnish, used to prevent areas of etching plate biting any further.

Tusche
Greasy lithographic drawing ink which can also be used in etching as an 'acid' resist.

Whiting
Comes in loose form or in blocks and used in etching process for drying excess ink from hand.

BIBLIOGRAPHY

Chamberlain, Walter, *Thames and Hudson Manual of Etching and Engraving*, (Thames and Hudson) 1972

Clemson, Katie, and Simmons, Rosemary, *The Complete Manual of Relief Printmaking*, (Dorling Kindersley) 1988

Croft, Paul, *Stone Lithography*, (A&C Black) 2001

Duffy, Kenneth, *Intaglio Printmaking*, (A&C Black) forthcoming

Gross, Anthony, *Etching, Engraving and Intaglio Printing*, (Oxford) 1970

Hoskins, Steve, *Water-based Screenprinting* (A&C Black) 2001

Lumsden, E. S., *The Art of Etching*, (Dover) 1962

Vicary, Richard, *Manual of Lithography*, (Thames and Hudson) 1976

Westley, Ann, *Relief Printmaking*, (A&C Black) 2000

Woods, Louise (ed.) *Practical Printmaking*, (Apple) 1996

'Pugilist', etching by Toni Martina, 61 cm x 45.7 cm (24 in. x 18 in.).
This image was made by drawing through a hard ground with a variable-speed
power drill onto a zinc plate; bitten in nitric acid.

LIST OF SUPPLIERS

Printmaking Equipment/Materials

American Printing Equipment & Supply Co.
42-25 9th Street
Long Island City
New York 11101-491, USA
Tel. +718 417 3939

Art Equipment Ltd
3 Craven Street
Northampton NN1 3E2, UK
Tel. 01604 32447

Artsup
Shop 7, Manning Street
Kingswood 2747, Sydney
NSW, Australia
Tel. +612 4736 5966

L. Cornelissen & Son Ltd
105 Great Russell Street
London WC1B 3RY, UK
Tel. 020 7636 1045

Daler-Rowney Ltd
12 Percy Street
London W1A 2BP, UK
Tel: 020 7636 8241

Intaglio Printmakers
62 Southwark Bridge Road
London SE1 0AS, UK
Tel. 020 7928 2711

T. N. Lawrence (Shops)
208 Portland Road
Hove
East Sussex BN3 5QT, UK
Tel. 01273 260280

38 Barncoose Industrial Estate
Pool
Redruth
Cornwall TR15 3RQ, UK
Tel. 01209 313181

117-119 Clerkenwell Road
London EC1R 5BY, UK
Tel. 020 7242 3534

Mail order: Tel. 01273 260260

Paintworks Ltd
99-100 Kingsland Road
London E2 8AG, UK
Tel. 020 7729 7451

Premier Art Supplies
43 Gilles Street
Adelaide, Australia
Tel. +618 8212 5922

Yorkshire Printmakers
26-28 Westfield Lane
Emley Moor
Nr. Huddersfield HD8 9TD, UK
Tel. 01924 840514

Metal for sheet zinc, copper, etc.

Fayes Metals Ltd
Unit 4
37 Colville Road
Acton
London W3 8BL, UK
Tel. 020 8993 8883

Smiths Metals Ltd
42-56 Tottenham Road
London N1, UK
Tel. 020 7241 2430

Printmaking Engineers

Harry F Rochat Ltd
15a Moxon Street, High Barnet
EN5 5TS, UK
Tel. 020 8449 0023

Modbury Engineering
Arch 311, Frederick Street
London E8, UK
Tel. 020 7254 9980

Presses

Art Equipment Ltd
3 Craven Street
Northampton NN1 3EZ, UK
Tel. 01604 632447

Nicholas Ward
38 Bulmer Lane
Winterton-on-Sea
Norfolk NR29 4AF, UK
Tel. 01493 393 570

Intaglio Printmakers
62 Southwark Bridge Road
London SE1 0AS, UK
Tel. 020 7928 2711

Paper

Atlantis
7/9 Plumber's Row
London E1 1EQ, UK
Tel. 020 7377 8855

Canson
2/9 Clarice Road
Box Hill, Melbourne
Victoria, Australia
Tel. +613 9899 9833

Dieu Donne Paper Mill
433 Broome Street
New York, USA
Tel. +212 226 0573

John Purcell
15 Rumsley Road
London SW9 0TR, UK
Tel. 020 7737 5199

Kate's Paperie
561 Broadway at Price Street
New York, USA
Tel. +212 941 9816

R. K. Burt & Co Ltd
57 Union Street
London SE1, UK
Tel. 020 7407 6474

The Paper Source
2112 Central street
Evaston, Illinois, USA
Tel. +847 733 8830

Linoleum

Ashmount Suppliers
77-79 Garman Road
London N17 0UN, UK
Tel. 020 8808 2158/3294

Ferric Chloride
(Available from some printmaking suppliers and some electrical wholesalers)

Nicol Graphics
Unit 11-19
Thurrock Commercial Centre
Juliet Way
London Road
South Ockendon
Essex RM15 4YG, UK
Tel. 01708 864551

Face Masks etc.
Available from hardware stores, home improvement/DIY stores

INDEX